DATE DUE

GOYA

GOYA

Enriqueta Harris

Phaidon Press Limited
2 Kensington Square, London W8 5EP

First published 1969
Second edition, revised and enlarged, first published 1994
This hardback edition first published 1994
© Phaidon Press Limited 1994

A CIP catalogue record for this book is available from the British
Library

ISBN 0 7148 3217 0

Printed in Singapore

Cover illustrations:
Front: *Portrait of the Duchess of Alba*, 1797 (Plate 10)
Back: *The Naked Maja*, c.1799-1800 (Plate 17)

The publishers would like to thank all those museum authorities and
private owners who have kindly allowed works in their possession to
be reproduced.

The author wishes to thank J. B. Trapp for his help in the preparation
of this text.

Goya

The greatness of Goya is more widely acknowledged today than ever before. He is known and appreciated everywhere as a portrait painter, as a creator of menacing and melancholy images in oils, as a master of enigmatic, satirical and revolutionary drawing and engraving, as the champion of the Spanish people in their struggle against oppression, and the recorder of their life and customs and their sufferings in war. Today every major collection in the world possesses some of his 292 engravings. These were published from Goya's own plates in successive editions, the most recent being issued in 1937, during the Spanish Civil War. These engravings are, of course, the most portable of Goya's works and therefore, in the physical sense, the most accessible. To judge his achievement as a painter, however, one must still go to Spain. Most of the chief galleries of Europe and the Americas contain, to be sure, examples of his painting, and some of these represent him at his best and most characteristic. But of approximately 500 works with any title to authenticity, nearly a third are in Madrid and almost half are preserved in Spain. No gallery outside Spain possesses more than a dozen.

Though Goya was in his lifetime the foremost painter in Spain, his fame in this medium did not extend to the rest of Europe. His only foreign patrons appear to have been the Duke of Wellington and the few Frenchmen who sat to him for their portraits – and most of these portraits were painted in Spain. He was little known abroad except as the author of his series of etchings, *Los Caprichos*. Even in Spain his reputation was in eclipse before he died. In 1828, the year of Goya's death, the catalogue of the Museo del Prado in Madrid, for which he himself had provided the autobiographical note, contained only three of his canvases: the equestrian portraits of Charles IV and his Queen and one other. Today the Prado possesses some 130 pictures. He had little or no immediate influence in his own country and when he retired at the age of 80 as First Court Painter (*Primer Pintor de Cámara*) he was succeeded, not by a pupil or follower, but by an exponent of the neo-classical style, Vicente López.

Goya moved to France in the last years of his life but this did not, apparently, make him better known in Europe. The first signs of his European reputation came after his death, among the new generation of French Romantics, who were admirers, in particular, of *Los Caprichos*. One of the earliest of these was Delacroix, who made copies of some of them. It was to him that the first monograph on Goya, published in Paris by Laurent Matheron, was dedicated in 1858. Before Matheron, writers such as Théophile Gautier and Charles Baudelaire had done much to make Goya's name known as a painter as well as an engraver, and the growth of *hispanisme* at that time, together with the publication in the 1860s of the *Desastres de la Guerra* (*The Disasters of War*) and the *Proverbios* (*Proverbs*) combined to make his influence more widespread. The generations of artists who succeeded Delacroix

reflect a growing admiration for the Spanish master: from Courbet to Manet and on to Picasso his presence is strongly felt. These later artists' respect for Goya's achievement contributes as much as anything to his reputation as the forerunner of so many movements in European painting of the nineteenth and twentieth centuries.

It is naturally for the revolutionary character of his art that Goya, the great Spanish Old Master, earned the title of 'first of the moderns'. But his originality can be fully appreciated only if it is seen in relation to his position as an 'official' artist and to his conventional professional career. For during most of his life – for 53 of his 82 years – Goya was a servant of the Spanish Crown and for nearly 30 years First Court Painter to three successive Spanish kings. Elected to the Royal Academy of San Fernando at the age of 34, in 1780, he was for several years its Deputy Director and Director of Painting, with teaching duties. By far the majority of his paintings were the result of official commissions: tapestry cartoons, portraits and religious subjects. It is his official works and the public honours that he won that take pride of place in Goya's early Spanish biographies, those by his son (1830) and by his friend Valentín Carderera (1835). Carderera also gives a hint of the rebellious character that legend later attributed to the painter on the evidence chiefly of his art: 'If Goya had written his life it would perhaps have afforded as much interest as that of Benvenuto Cellini.'

Modern investigations of his 'unofficial' works, particularly the graphic art, have thrown much light on Goya's critical attitude to many aspects of the contemporary world. Much has been done to dispel the mystery that once surrounded Goya and his work: the monumental catalogue of Pierre Gassier and Juliet Wilson-Bareau, recording and illustrating Goya's enormous oeuvre (1,870 paintings, drawings and engravings); many recent important studies and exhibitions; and the publication of a large number of documents and letters. But there remain gaps in our knowledge as well as many problems of authorship, chronology and interpretation. One of the mysteries that is perhaps too deep ever to be solved is that first propounded by his biographer Laurent Matheron, more than 100 years ago: '*Comme ce diable d'homme devait se trouver à l'étroit dans son costume de peintre du roi*' ('How this devil of a man must have found himself constricted in his costume of painter to the King').

Francisco José Goya y Lucientes was born on 30 March 1746, at Fuendetodos, an Aragonese village near Saragossa (Fig. 1), and died at Bordeaux on 16 April 1828. The first half of his life was spent under the peaceful and relatively enlightened rule of Charles III. The second half was lived in a turbulent atmosphere of political and social unrest, which reflected and was created by the events in France that led to and followed the Revolution, in a period of foreign invasion and civil war, succeeded by a wave of reaction that led Goya eventually to seek voluntary exile in France. Goya's enormous output of paintings, drawings and engravings, produced during a working life of more than 60 years' passionate activity, record innumerable aspects of the life of his contemporaries and the changing world in which he lived. It also reflects the personal crises which were the result of illness, in particular that which left him permanently and totally deaf at the age of 47.

Not much is known of Goya's early life as a painter but it seems to have followed a conventional pattern. The son of a master gilder, he began his artistic studies in Saragossa at the age of 13 with a local artist, José Luzán, who had trained in Naples and who taught him to draw, to copy engravings and to paint in oils. In 1763 and 1766 he competed unsuccessfully for scholarships offered by the Royal Academy of San Fernando in Madrid, probably working during this time in the

Fig. 1
Goya's home in
Fuendetodos

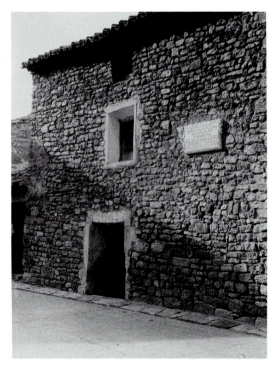

studio of the Court Painter Francisco Bayeu (Plate 9), a fellow towns-man whose sister Goya married in 1773. Unable to gain support for a journey to Italy, he went to Rome at his own expense, according to his son, to continue his studies. Goya himself later asserted that he had supported himself there, presumably by his brush. His meeting with the painter Jacques-Louis David, which Matheron reports Goya as having spoken of in his old age, is problematical: David was not in Italy at the time and there is no evidence that the two great contemporary artists ever met. All that is known for certain of Goya's Italian sojourn is that in April 1771 he was in Rome and from there submitted a painting to a competition held by the Academy in Parma, which had been announced in the previous year. He described himself as a Roman and a pupil of Bayeu. Goya's entry (known today only from a damaged sketch) had for its subject Hannibal's first sight of Italy from the Alps. It won six votes and the comment that 'if his colours had been truer to nature and his composition closer to the subject it would have created doubts about the winner of the prize'. The winner was Paolo Borroni, a painter of little note today.

It is not known how long Goya was in Italy. All we have to go on is his son's statement that Goya's affection for his parents made him cut short his stay and the knowledge that by the end of 1771 he was back in Saragossa and receiving his first official commission, which was for frescoes in the Cathedral of El Pilar. Since there are no paintings that can be dated with certainty before 1771, it is difficult to determine what Goya learned from his visit to Italy. It is possible that he acquired the technique of fresco painting there, but against that we must set the fact that his first frescoes in Saragossa show the influence of the rococo styles of Italian artists whose works he could have seen without leaving Spain. For example the Neapolitan, Corrado Giaquinto, traces of whose style have been discerned in Goya's early work, had been active in Spain for many years and after Giaquinto's departure the Venetian Giovanni Battista Tiepolo had executed many commissions there. Tiepolo, with his two sons, was employed at the Spanish court from 1762 until his death in 1770. His work was one of the principal formative influences on Goya's earliest known style and it is even possible that Goya met him in Madrid before he went to Italy.

The next important influence came from a very different source, the German artist Anton Raphael Mengs, the friend of Winckelmann and celebrated exponent of neo-classicism. Mengs had gone to Spain as Court Painter the year before Tiepolo and when he returned there from a visit to Italy in 1773, after Tiepolo's death, he became undisputed art dictator. Indeed, according to his English translator, 'he enjoyed such fame that not to admire him was almost a violence against Church and State'. It is possible that it was in Rome that Goya first met Mengs, since many years later he wrote that it was Mengs who made him return to Spain. In any event, it was Mengs who started him on his career at court by summoning him in 1774 to work, with other young artists, on designs for tapestries to be woven at the Royal Factory of Santa Barbara. Under the direction first of Mengs, and later of Francisco Bayeu and Mariano Maella, Goya produced over 60 tapestry cartoons at intervals between 1775 and 1792.

These cartoons are important both from the point of view of the subjects represented and because of the stylistic development to which they bear witness. In the first place, they gave Goya his first opportunity to use those national subjects for which he was later so famous. Until Mengs's time the tapestries woven in Madrid had been based on literary, allegorical and peasant themes after French and Flemish paintings. Goya and his fellow artists were allowed for the

first time – subject to the approval of their designs by the King – a much freer hand. Original compositions and new subjects, portraying typically Spanish scenes, now became the vogue, and we find the writer Antonio Ponz in 1782 commending the recent tapestries based on paintings by Goya and other artists for representing 'the costumes and diversions of the present time'. These scenes of contemporary life, particularly of life in Madrid, illustrations of aristocratic and popular pastimes – *fêtes galantes à l'espagnole* – reflect the new taste for such topics which is also evident in contemporary Spanish literature, especially in the theatre. In painting Goya was to exploit them more than any other Spanish artist of his age.

It is this new subject matter which is singled out by the French ambassador Bourgoing, whose *Nouveau Voyage en Espagne* was first published in 1789. Goya is mentioned as one of the painters who helped to recompense the Spaniards for the loss of Mengs and is praised for the 'pleasing style in which he portrays the manners, customs and games of his country'. Mengs, in fact, had left Spain in 1776, but his presence is evident in the early cartoons, where the influence of Tiepolo's decorative style is modified by the teaching and example of the German painter, especially his insistence on simplicity and selective naturalism. In the course of his work on the tapestry cartoons, Goya developed a growing independence of foreign influences and an increasingly individual style, largely inspired by the study of Velázquez – the artist who was for Mengs the greatest exponent of the 'natural style'. In around 1778 Goya made a series of 16 etchings after paintings by Velázquez in the royal collection, which are amongst his earliest engravings. Later in his life he acknowledged Velázquez as one of his three masters, the others being Rembrandt and 'above all, nature'. Rembrandt's influence, which must have come almost entirely from the etchings, of which he owned several, is certainly visible in Goya's later drawings and engravings, but it was to Velázquez and to nature that his art owed most. Velázquez's example influenced his approach to nature and provided the model for the 'impressionistic' technique that Goya was to develop further than any artist of his age. As his friend Carderera was to put it: 'The continual study of Nature and the close observation of the works of the great Velázquez and of Rembrandt formed that style which is the delight of intelligent people and *aficionados*. From the Dutch painter our artist learned that great economy which he used in the lighting of his pictures so as to create that piquant and emphatic effect that surprises and pleases even the most ignorant. From the famous Sevillian he took his admirable understanding of aerial perspective, that effect of vapour or interposed air which characterizes all the pictures of his second and last period, that bold and firm execution and finally, that special touch with which the great Velázquez summarily indicated details in the attempt to direct the spectator's eye to the principal subject without allowing irrelevant accessories to distract his attention.'

Goya's later cartoons present the same baffling stylistic contradictions as the rest of his work, but they are in many respects more independent of influence from his contemporaries than the early ones. The cartoons, being well documented, can be dated exactly: on stylistic evidence alone, dating would be problematic. Even late in this period of growing independence, Goya reverts to an earlier conventional manner and method of composition when the subject seems to demand it. The *Blind Man's Buff* (Plate 6) and *The Straw Manikin* (*El Pelele*) (Plate 7), for instance, with their stiffly posed figures with frozen expressions, are altogether less naturalistic than *The Injured*

Mason (Plate 2). The more informal the subject, the more realistically it is portrayed. Goya did not always take into consideration the function of the cartoons – the *Blind Guitarist*, one of his own inventions, was returned to him for alteration when the tapestry weavers found it impossible to copy.

It was probably an exaggeration on the part of Goya's son to write that his father's extraordinary facility in painting tapestry cartoons 'astonished' Mengs. Nevertheless, Goya had certainly made an impression on his director, for when he applied in 1776 for an appointment as Painter to the King (*Pintor del Rey*), he was recommended by Mengs as 'a person of talent and spirit who is likely to make great progress'. This good opinion did not secure Goya the appointment on that occasion or at his next application three years later, after Mengs had left Spain, even though he had the additional support then of Bayeu and Maella. He did not finally obtain the post until 1786. Meanwhile, in 1780, his application for membership of the Royal

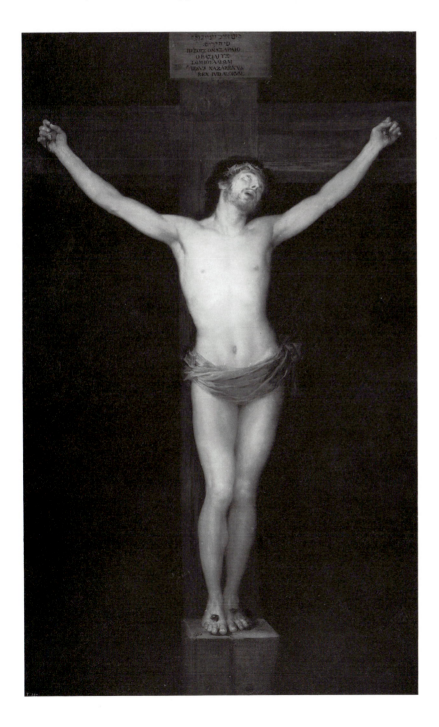

Fig. 2
Christ on the Cross
1780. Canvas, 255 x 153 cm. Museo del Prado, Madrid

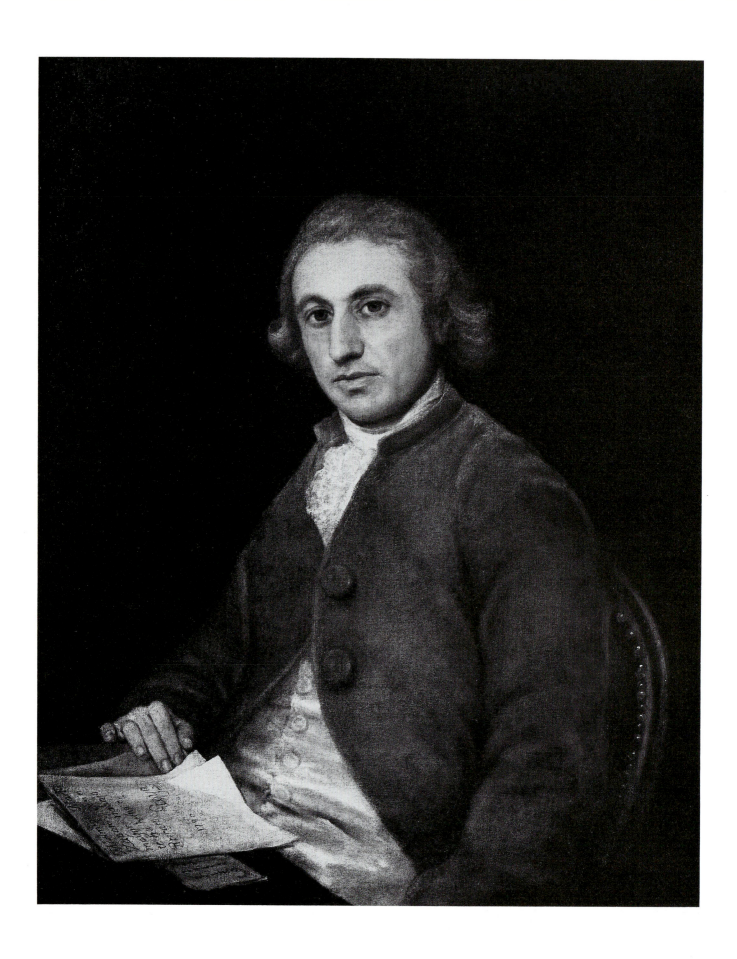

Academy of San Fernando had been unanimously approved. His admission piece was a *Christ on the Cross* (Fig. 2), a conventional composition in the manner of Mengs or Bayeu but somewhat influenced by the more naturalistic treatment of Velázquez, whose painting of the same subject he may have known. Shortly afterwards, Goya returned to Saragossa to paint the new frescoes in the Cathedral of El Pilar, a commission which involved him in violent altercation with the authorities and a quarrel with Bayeu, to whom he was reluctantly obliged to submit his sketches.

After his return to Madrid in 1781, Goya received the royal invitation to paint one of seven large altarpieces for the newly built church of San Francisco el Grande, in preference to Bayeu, Maella and other court painters. Goya welcomed the opportunity to further his own ambition and prove his worth by participating in this 'greatest enterprise in painting yet undertaken in Madrid'. As he wrote to his friend and chief correspondent in Saragossa, Martín Zapater (see Fig. 3), the invitation would be the means of silencing his detractors, 'those malicious people who have been so mistrustful of my merit'. Goya made several sketches for his painting, which occupied him for more than a year. The result, *St Bernardine Preaching*, still *in situ*, is a conventional pyramidal composition, which is today chiefly interesting for the self-portrait which he introduced among the heads of the spectators. For Goya, it represented a personal triumph as well as a stepping stone in his career. 'Certainly,' he wrote to the same correspondent, 'I have been fortunate in the opinion of intelligent people and of the public at large...since they are all for me, without any dissentient voice. I do not yet know what result will come from above: we shall see when the King returns to Madrid.' The King's opinion must have been favourable, for, a year after the paintings were first shown to the public – that is in 1785 – Goya was appointed Deputy Director of Painting in the Academy. In 1786 his desire to be made Painter to the King was at last realized.

Goya was now launched as a fashionable court painter and entered upon the most productive and successful period of his life. 'I had established for myself an enviable way of life,' he wrote to Zapater in 1786, 'no longer dancing attendance on anyone. Those who wanted something of me sought me out. I made myself more in demand, and if it was not someone very grand or recommended by some friend then I wouldn't work for them, and just because I made myself so indispensable they did not (and still do not) leave me alone so I do not know how I am to carry out everything...' This was no empty boast. Anyone who was anyone appears to have wanted to sit to Goya: the royal family, the aristocracy and court officials. In 1783, he painted the portrait of the Chief Minister of State, the Count of Floridablanca, in which Goya himself appears. In the same year he painted the family portrait of the Infante Don Luis, the King's brother, with himself again in the picture, and in the following year the court architect, Ventura Rodríguez, sat to him. In 1785, he was commissioned for a series of portraits of officers of the Banco Nacional de San Carlos. In these early official portraits, Goya adopted conventional eighteenth-century poses, and only slightly modified the polished finish of Mengs. His portraits of society ladies in outdoor settings recall contemporary English portraits as well as his own tapestry cartoons. In such portraits as that of the Marchioness of Pontejos (National Gallery of Art, Washington, DC), the stiff elegance of the figure and the fluent painting of the elaborate costume reflect his study of Velázquez's Infantas. His portrait, *Charles III in Hunting Costume* (Fig. 4), is based directly on Velázquez's paintings of royal huntsmen.

Fig. 3
Martín Zapater
Reading a Letter
from Goya
Canvas, 83 x 65 cm.
Private collection
Signed '*Goya 1790*'.

Fig. 4
Charles III in
Hunting Costume
c.1786-8. Canvas,
206 x 130 cm. Collection
Fernán-Núñez, Madrid

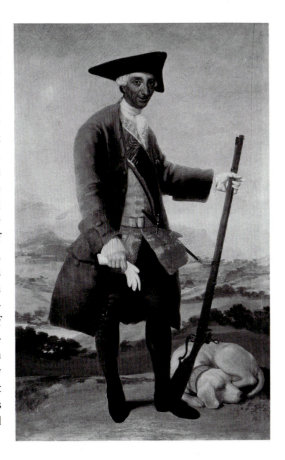

Among Goya's early admirers and most important patrons during a period of 20 years were the Duke and Duchess of Osuna, who commissioned not only portraits of themselves and a family group but also a number of paintings to decorate their country residence near Madrid, the Alameda Palace, known as El Capricho. These paintings are similar in character to the tapestry cartoons and close in style to the sketches for them but the range of subjects is wider. In addition to the genre scenes, there are some which appear to represent actual occurrences – bandits attacking a coach, a woman fainting after falling from an ass (Plate 3) – as well as representations of witchcraft, two of which are based on scenes from plays (Plate 13). Among other paintings for the Duke of Osuna are two altarpieces, commissioned in 1788 for the chapel of his ancestor, St Francis Borgia, in Valencia Cathedral, which are more dramatic in character and treatment than any of Goya's earlier religious compositions.

The death of Charles III in 1788, a few months before the outbreak of the French Revolution, brought to an end the period of comparative prosperity and enlightenment in Spain in which Goya had slowly reached maturity. The rule of reaction and political and social corruption that followed – stimulated by events in France – under the weak and foolish Charles IV (Fig. 5) and his clever, unscrupulous Queen, María Luisa, was to end in the Napoleonic invasion of Spain.

Under the new régime Goya reached the height of his career as the most fashionable and successful artist in Spain. The new King raised him to the rank of Court Painter in 1789 and in 1792 he felt his position in the Academy assured enough to submit a report on the study of art, recommending the setting aside of the form of teaching established by Mengs, which had prevailed there. At the death of Francisco Bayeu in 1795, Goya succeeded his former teacher as Director of Painting in the Academy (but resigned for reasons of health two years later), and in 1799 was appointed First Court Painter. Goya evidently welcomed official honours and worldly success with almost naïve enthusiasm. 'The King and Queen are mad about your friend Goya', he wrote, announcing this last honour to his friend in Saragossa. Yet the record that he has left in paint of some of his patrons – including members of the royal family – is ruthlessly critical.

During a visit to Andalusia towards the end of 1792, Goya was struck down by a long and serious illness of which the effect, as he wrote even a year later, made him, 'at times rage with so ill a humour that he could not tolerate himself'. The nature of the illness is not known for certain but it caused temporary paralysis and partial blindness and left him permanently deaf, so that henceforth he could only communicate by writing and sign language. He returned to Madrid in the summer of 1793 and in the following January sent a series of 11 small paintings to Bernardo de Iriarte, Vice Protector of the Academy, with a covering letter in which he wrote: 'In order to occupy an imagination mortified by the contemplation of my sufferings and to recover part of the very great expense they have occasioned, I devoted myself to painting a group of cabinet pictures in which I have succeeded in making observations for which there is normally no opportunity in commissioned works, which give no scope for fantasy (capricho) and invention.' The paintings were shown at a meeting of members of the Academy who expressed their approval of what were described as 'various scenes of national pastimes', applauding their merit and that of the artist. The rediscovery of the twelfth painting sent to the Academy a few days later, representing *The Yard of a Madhouse* (Plate 8), has provided a touchstone for the identification of the others of the series. The painting corresponds exactly to the

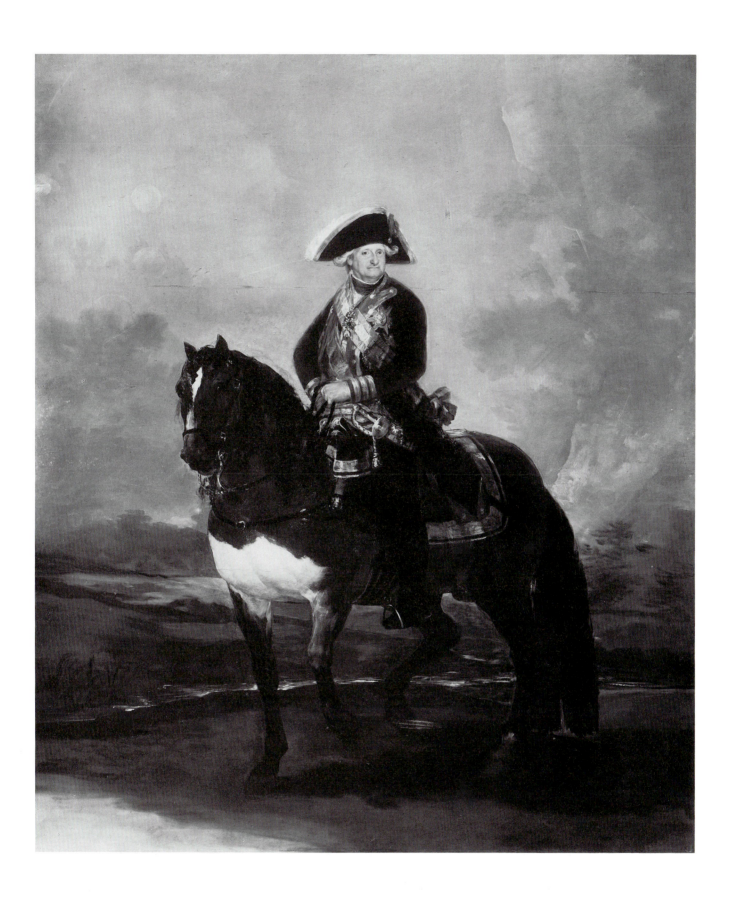

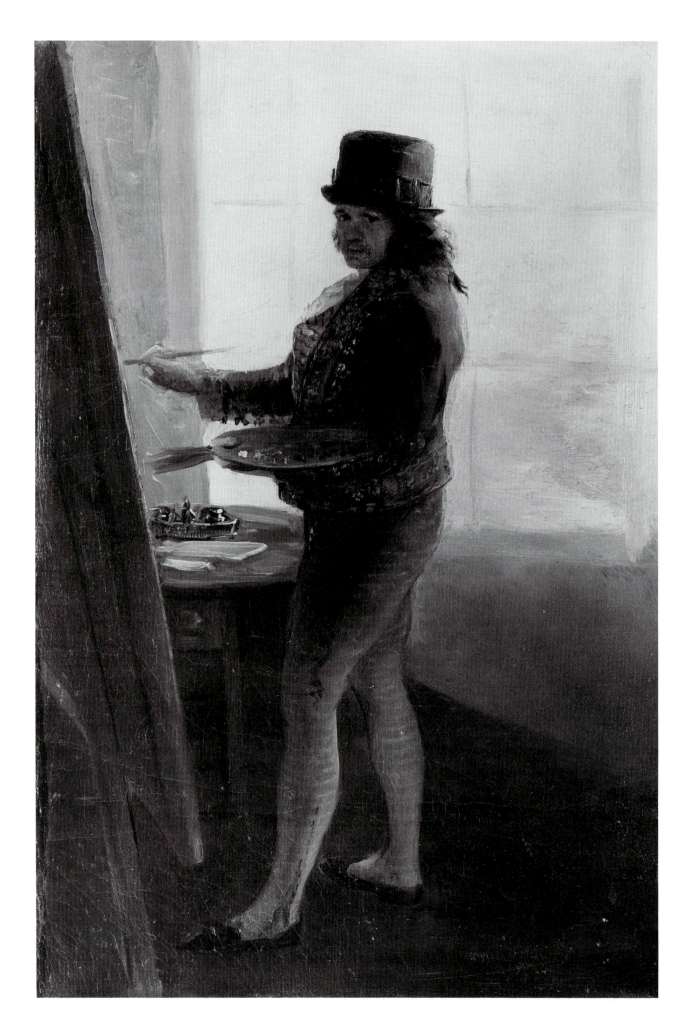

description in Goya's covering letter of a scene he had actually witnessed. Consequently, the five small paintings in the Academy (Plates 27-30), once thought to have been among the dozen 'cabinet pictures', are now attributed to a much later date, even to the war years. Their free, sketchy technique with bold splashes of colour and black outline are now seen to be consistent with, rather than foreshadowing, a later style. At the same time, these pictures are a further example of the increasing variety of Goya's manner. His range of subject, too, was widening in all three media – painting, drawing and engraving. From now on uncommissioned works gave full scope to 'observation', 'fantasy' and 'invention'. For his commissioned works Goya continued to use the conventional formulas.

It was undoubtedly as a portrait painter that Goya won fame and advancement and the special praise of Carderera, who observed his 'astonishing facility for portrait painting. He customarily painted portraits in a single session and these were the most life-like.' To this Goya's son added a detail that explains the unusual hat, with metal candlesticks around the crown, that he wears in the *Self-portrait* in his studio (Fig. 6; compare Fig. 7): 'He painted only in one session, sometimes of ten hours, but never in the late afternoon. The last touches for the better effect of a picture he gave at night, by artificial light.' Goya's biographer, Matheron, also commented on this practice: 'He was so jealous of the effect that – like our Girodet who painted at night, his head crowned with candles – he gave the last touches to his canvases by candlelight.'

In the years after his illness Goya produced some of his most sensitive and delicately painted portraits – for instance the silvery-toned

Fig. 6
Self-portrait
c.1785-90. The artist at his
easel, wearing his studio
hat. Canvas, 42 x 28 cm.
Royal Academy of San
Fernando, Madrid

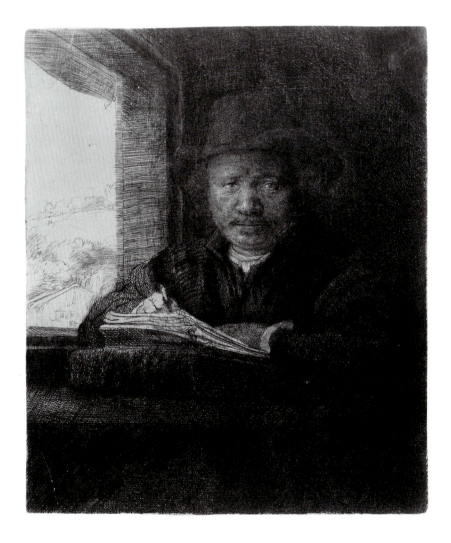

Fig. 7
Self-portrait Drawing
at a Window by
Rembrandt van Rijn
1648. Etching,
15.7 x 12.8 cm
Signed '*Rembrandt f. 1648*'

Fig. 8
Self-portrait
1799. From the series *Los Caprichos*, Plate 1. Etching and aquatint, 21 x 15.2 cm
Signed '*Franc^{co} Goya y Lucientes Pintor*'

likenesses of Francisco Bayeu (Plate 9), Andrés del Peral (Plate 14), and the intimate yet formal portrait of his friend and protector, the liberal minister and writer, Gaspar Melchor de Jovellanos (Plate 15). The characterization of the heads, which is so notable in these paintings, is surprisingly absent in the two delicately but stiffly painted portraits of the Duchess of Alba, of the same period. In each case the face of the Duchess, famous for her beauty, is that of a painted doll; there is no hint in the execution of the portrait of 1797 (Plate 10), for example, of the intimacy known to have existed between the artist and the sitter. On the contrary, it is carefully veiled: only the inscription, long covered up, to which she points seems to indicate the nature of the relationship: '*solo Goya*'. Yet at the time when he painted this portrait, during his stay at her Andalusian estate after her husband's death, Goya was recording, in a sketchbook, many lively, intimate scenes in the everyday life of the Duchess and her household.

At about this time Goya was also making drawings for a very different purpose, the series of 80 etchings published in 1799 called *Los Caprichos* (Fig. 8). In these the artist used the popular imagery of caricature in a highly original and inventive form for his first essay in the criticism of political, social and religious abuses, for which he is famous. His mastery of the recently developed technique of aquatint makes these etchings a major achievement in the history of engraving. Despite the veiled language of *Los Caprichos* they were withdrawn from sale after a few days. Yet, in one of those apparently inexplicable contradictions in which the life of Goya abounds, when the plates and surplus copies were offered to the King in 1803 they were accepted and Goya was rewarded with a pension for his son. Many years later, Goya spoke of having nevertheless been denounced to the Inquisition

– at what date and with what consequences we do not know. His friend Carderera commented with admiration on Goya's daring: '*Los Caprichos* and other single compositions, both in painting and engraving, reveal his satirical spirit, his lively understanding, his enlightenment and also a certain greatness of spirit which enabled him to ridicule and criticize the vices and excesses of people who at the time were extremely powerful.' What we do know is that only a few months after the publication of *Los Caprichos* Goya was promoted to the rank of First Court Painter.

Whether or not *Los Caprichos* were withdrawn for political reasons, Goya's success and official position with his royal patrons appears to have been unaffected at the time either by them or by his increasingly unconventional treatment of conventional subjects. His fresco decorations in the church of San Antonio de la Florida, a royal commission executed in 1798 in the space of a few months (Fig. 19, Plate 12), owe little to earlier religious frescoes. The over life-size figures are painted in a broad and free style, in strong colours, with hardly any detail – a style that, indeed, has no precedent in Goya's oeuvre. Though Goya in this same period was painting religious subjects such as the *St Gregory* (Plate 11), and the *Taking of Christ* in the Sacristy of Toledo Cathedral in a traditional manner, here he has concentrated on the overall effect. The *Miracle of St Anthony*, the central theme, is almost overshadowed by the surrounding populace and by the angels in the shape of contemporary women below.

Even less conventional than the San Antonio frescoes are Goya's portraits of his royal patrons. From the time of their accession until 1800, Charles IV and María Luisa sat to him on many occasions, and many replicas were made of his portraits of them. He painted them in various costumes and poses, ranging from the early decorative portraits in full regalia in the existing tradition of Mengs to the simpler and more natural compositions in the manner of Velázquez, who directly inspired the large equestrian portraits in the Museo del Prado (Fig. 5). But while following traditional compositions for these state portraits, Goya creates an effect of pomposity rather than majesty and the faces of his sitters reveal a penetrating scrutiny of character. Nowhere is this more striking than in the portrait of *Charles IV and his Family* (Plate 16). Though Goya doubtless had in mind Velázquez's unique royal portrait, *Las Meninas*, which he had copied in an engraving years before (Fig. 22). Goya, like Velázquez, has put himself in the picture at his easel (Fig. 23), but his royal assembly lacks any semblance of courtly dignity and elegance. Moreover, despite the official character of the painting and his official position, he has accentuated the ugliness and the vulgarity of the principal figures so vividly as to produce an effect almost of caricature. Théophile Gautier, writing of this picture, remarks that the King 'looks like a grocer who has just won the lottery prize, with his family around him'.

Goya as First Court Painter seems to have been more ready than ever to express an opinion of his sitters in his portraits of them. The portrait of the Countess of Chinchón (1800), for example, is a sympathetic portrayal of the young pregnant wife of Manuel Godoy, 'Prince of the Peace' and Chief Minister, and the lover of Queen María Luisa. Godoy's own portrait, painted in the following year (Plate 19), is a somewhat theatrical composition, which may hint at the disrespect that was almost certainly intended in several plates of *Los Caprichos*. Godoy was, nevertheless, an important patron of the artist. His palace was decorated with allegorical paintings by Goya, he not only sat to him on more than one occasion for his portrait but had his wife painted by him, and he owned versions of Goya's portraits of the King and

Queen. It is, moreover, in Godoy's collection that *The Naked Maja* (*La Maja Desnuda*) (Plate 17) and *The Clothed Maja* (*La Maja Vestida*) (Plate 18) are first recorded, and the importance of his position makes it possible that they were painted for him. The possibility is strengthened by his own taste – he owned among other such pictures Velázquez's *The Toilet of Venus* ('*The Rokeby Venus*') (Fig. 24) – but it cannot be asserted that he actually commissioned Goya's only painting of a female nude. Both the origin of the *Majas* and the identity of the model are still a mystery. Goya was summoned by the Inquisition in 1815 to explain when and for whom they had been executed, but his explanation has never been brought to light.

At about the same time that the *Majas* were probably painted, that is, around 1800-3, Goya seems to have suffered a loss of royal favour. The group portrait is the last occasion on which he painted either Charles IV or María Luisa, and in 1804 he was unsuccessful in his application to be made Director General of the Academy. The decline in favour has never been satisfactorily explained, though a variety of suggestions have been advanced. Among these are the notoriety of *Los Caprichos* (Goya's gift of the plates to the King in 1803 is thought by some to have been an attempt to protect himself); Goya's political sympathies (his protector Jovellanos was imprisoned in 1801); his liaison with the Duchess of Alba and the circumstances of her death in 1802; and the change of taste exemplified in the appointment of Vicente López as Court Painter in 1802. The true cause may well be a royal preference for López's more flattering, neo-classical style of portraiture.

Despite Goya's loss of official patronage, the years preceding the French invasion were prosperous and fruitful. He was rich enough to purchase a second house which he gave to his son, Francisco Javier, the only surviving child of several (though not the legendary 20) when he married in 1805. Goya's production consisted chiefly

Fig. 9
Portrait of Javier
Goya, the Artist's Son
1824. Black chalk,
9 x 8 cm. Lehman
Collection, New York, NY
Signed '*Pr. Goya año 1824*'

of portraits but these were of a wider range of sitters than hitherto: his son and daughter-in-law (Figs. 9, 27), men and women whose names are known today only because he painted them, others whose names have been forgotten, as well as some members of the court and aristocracy. In 1805, perhaps a few years after the *Majas*, he painted in a similar pose the Marchioness of Santa Cruz (Museo del Prado, Madrid), daughter of his earlier patrons, the Duke and Duchess of Osuna, a young woman said to have had a taste for the unconventional. But though she is more lightly clothed than the clothed *Maja*, her attributes of wreath and lyre and the more polished style of the painting produce a more formal effect. Goya's uncommissioned works of this period include two paintings of *Majas on a Balcony*, recorded in the artist's possession in 1812.

Goya was 62 years old when the old régime in Spain finally collapsed, with the aid of Napoleon, and Spain was subjected to six years of war and revolution. The rapidity and confusion of the events of 1808, when the French crossed the frontier, are reflected in the history of the equestrian portrait of Ferdinand VII (Madrid, Royal Academy of San Fernando). Goya was ordered to paint this portrait in March, after the rising at Aranjuez which had forced the resignation of Godoy and the abdication of Charles IV. Only three sittings of three-quarters of an hour were allowed him and the picture was not exhibited until October of that year. In the meantime Napoleon had forced Ferdinand from the throne in favour of his own brother Joseph and the French had entered and been temporarily expelled from Madrid.

Goya's conduct and his continued practice in his profession during the war were in some ways equivocal but in this he was no different from many of his fellow countrymen and friends. He was in Madrid during the tragic events of 2 and 3 May when the populace rose against the French and the rising was savagely repressed, incidents which he later recorded in two of the most famous of his paintings (Plates 36 and 37). After the temporary liberation of the capital he was summoned by General Palafox to Saragossa, which had recently been under siege, to inspect the ruins and record the glorious deeds of its inhabitants.

Goya is next heard of in Madrid towards the end of 1801, when the French were again in occupation, and with thousands of other heads of families Goya swore allegiance to the French King. He also seems to have resumed his activities as Court Painter and in March 1811 was awarded Joseph's decoration, the Royal Order of Spain. Goya was one of three academicians ordered by Joseph to select 50 Spanish pictures from palaces and churches for the Musée Napoleon in Paris and seems to have done so only after long delay. When the pictures reached Paris it was reported that at the most six were worthy to enter the museum. During the French occupation Goya painted the *Allegory of the City of Madrid* (Plate 24), with a portrait of Joseph which he copied from an engraving. There is no record of Joseph sitting to Goya, though several French generals and pro-French Spaniards did so. As soon as Wellington entered Madrid in 1812, Goya accepted a commission for an equestrian portrait of the liberator and, probably soon afterwards, painted one other portrait of his only recorded English sitter (Plate 34). During the war he was also occupied with portraits of family groups and private citizens. His uncommissioned works of the period include many paintings of the hostilities themselves and one symbolic picture, the fearful and enigmatic *Colossus* (Plate 32). But the most moving and eloquent record that he made of the war and of his personal reactions to it are the *Desastres de la Guerra*, a series of 82 etchings for which he made drawings at the time, though they were not pub-

Fig. 10
Portrait of Goya by
Vicente López
1826. Museo del Prado,
Madrid, Signed 'López a su
Amigo Goya'

lished until 1863. If Goya had ever looked upon the French as libera-
tors, the *Desastres* express his fierce hatred of the effects and conse-
quences of war, just as other drawings of the period bear witness to a
more generalized but no less fervent abhorrence of injustice, oppres-
sion and hypocrisy.

At the end of the war Goya and other Spaniards who had served
the French King were subjected to 'purification'. Goya defended
himself by claiming that he had never worn Joseph's decoration and
that it had only compromised him, and several witnesses supported
this statement. His defence was accepted and Goya resumed his
office as First Court Painter on the restoration of Ferdinand VII. Even
before the King's return, he had applied to the Regency for permis-
sion to commemorate the incidents of 2 and 3 May (Plates 36 and 37).
Soon afterwards he was commissioned to paint several portraits of the
King for ministries and other public buildings. For these, Goya seems
to have used the same study of the head, changing only pose, setting
and costume to suit the occasion. The portraits (Plate 35) are remark-
able for a characterization that comes even closer to caricature than
the portraits of María Luisa: their pompous attitudes and subtly exag-
gerated facial expressions evoke the cruel, despotic character of the
rey deseado ('desired king') whose restoration to the throne inaugu-
rated a new era of fanaticism and oppression. The portraits of
Ferdinand were Goya's last royal portraits, apart from the appearance
of the King in the *Royal Company of the Philippines* (Musée Goya,
Castres). Goya was again out of favour. Whether or not his image of
the King was felt to be objectionable, Ferdinand clearly preferred the
more pleasing style of Vicente López (see Fig. 10) for portraits of
himself and his family.

It may be too that Goya's liberal sympathies did not recommend
him at Court. Ferdinand's reactionary measures immediately after his
restoration, his repudiation of the Constitution of 1812, the re-estab-
lishment of the Inquisition, the closing of universities and theatres,
the introduction of press censorship and the persecution of the liber-
als, including many of Goya's friends, must certainly have antago-
nized the artist. Although he was exonerated from the charge of
having 'accepted employment from the usurper' in April 1815, it was
at that time that he was summoned to appear before the Inquisition
on account of the *Majas*. Nevertheless, Goya retained his position as
First Court Painter for another decade.

Apart from the publication in 1816 of the *Tauromaquia*, a series of
etchings of the national sport of bullfighting, from now on Goya was
chiefly occupied with paintings for private patrons, for friends and for
himself. He also continued to record in the more intimate medium of
drawing his observations and ideas. Freed from official restrictions,
his style became more and more personal and his technique increas-
ingly free and impressionistic as in *Time and the Old Women* (Plate 26),
A Woman Reading a Letter (Plate 25) and *The Forge* (Plate 39). A similar
development is visible in the gradually changing style of the portraits
he painted at this time. The poses, except in the case of a few official
sitters, became less formal and Goya developed his technique of cre-
ating a remarkable effect of likeness by means of a minimum of
detail. Pose and technique are strikingly illustrated in the self-portrait
with his doctor painted in 1820 to commemorate his recovery from
serious illness the year before (Plate 43). Goya shows himself sup-
ported in the arms of the physician, the melancholy expression that
he had worn in the self-portrait of 1815 (Plate 38) now deepened and
transmuted by suffering.

It is perhaps surprising that during this period of semi-retirement

Goya should have received two important ecclesiastical commissions, for the *St Justa and St Rufina*, painted in 1817 for Seville Cathedral, and for *The Last Communion of St Joseph of Calasanz*, painted in 1819 for the church of the Escuelas Pías de San Antón in Madrid (Plate 42). In these he adapted his late style to traditional subject matter and turned to seventeenth-century Spanish painting for his models. While the Seville picture has been criticized for its profane character, *The Last Communion* is more suggestive of religious devotion than any of Goya's earlier religious works. No hint of anything so conventional is apparent in the famous 'black paintings' now in the Prado (Plates 45 and 46), the terrifying images with which he decorated his house on the outskirts of Madrid, the Quinta del Sordo ('the house of the deaf man'). These paintings must have been executed between 1820, after his illness, and 1823 when Goya made over the Quinta to his grandson. Their entirely new, expressionistic language and grim fantasy make them, along with the *Proverbios* or *Disparates* (a series of etchings made about the same time, though not published until 1864) the most private and tortuous of all his works. Their subjects are sinister, horrific and mysterious, and their atmosphere of nightmare seems the product of cynicism, pessimism and despair.

Paradoxically, the period of the painting of the Quinta corresponded to a liberal interlude, forced upon Ferdinand by widespread revolt, but lasting only three years. When the French army restored the King to absolute power in 1823, the persecution of the liberals was renewed with greater violence than ever before. Goya, who had made his last appearance at the Academy on 4 April 1820 to swear allegiance to the Constitution, went into hiding early in 1824. Many of his friends had already left the country or were in similar concealment. After the declaration of amnesty of that year, in May he applied for – and was granted – leave of absence to travel to France, allegedly to take the waters at Plombières for his health. He went first to Bordeaux, where several of his friends had settled, arriving there in June, according to one of them 'deaf, old, slow and feeble – and so happy and so eager to see the world'. From Bordeaux he went on to Paris, where he spent two months in the company of Spanish refugees, leaving the house, according to the police record 'only to see the sights of the city and to roam the streets'. Back in Bordeaux, Goya set up house with Leocadia Weiss, who had come from Spain with her two children, for the younger of whom he is known to have had a special affection. He taught her to draw and had great, but unfulfilled, hopes of her talent.

Goya remained in Bordeaux for the rest of his life, except for two short visits to Madrid in 1826 and 1827. On the former he offered his resignation as First Court Painter and was pensioned off. 'I am 80 years old,' he wrote to the King, 'I have served your august parents and grandfather for 53 years.' During the visit he sat to Vicente López, his successor (Fig. 10). Until the end of his life Goya, in spite of old age and infirmity (Fig. 11), continued to record the world around him in paintings and drawings and in the new technique of lithography which he had already begun to use before leaving Spain. 'Sight and pulse, pen and inkwell, everything fails me and only my will is to spare', he wrote to his friend Joaquín Ferrer in Paris in December 1825. But even now he was turning to something new. In the same letter, evidently a reply to a suggestion that *Los Caprichos* would be saleable in Paris, he announced that he had 'better things today which could be sold to greater effect. To be sure,' he continued, 'last winter I painted on ivory a collection of nearly 40 examples, but it is original miniature painting such as I have never seen for it is not done with

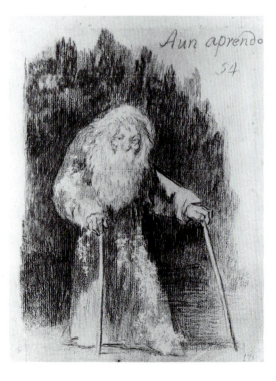

Fig. 11
'I am Still Learning'
('*Aún aprendo*')
1824-8. Black chalk,
19.5 x 15 cm. Museo
del Prado, Madrid

Fig. 12
Young Woman,
Half-naked, Leaning
against Rocks
1824-5. Miniature on
ivory, 8.8 x 8.6 cm.
Museum of Fine Arts,
Boston, MA

stippling and they look more like the brushwork of Velázquez than of Mengs.' A number of these miniatures have survived and are indeed original in subject matter, style and technique. Instead of the usual portraits, Goya shows such subjects as a young woman, half-naked, leaning against rocks (Fig. 12), a monk talking with an old woman, a *majo* and *maja*. Instead of the careful finish usual in miniatures, we have the broad sketchy style of Goya's last years. His technique, so different from that of the conventional miniaturist, is described by Matheron, whose information about Goya's years in Bordeaux is based on the first-hand evidence of the artist's companion and compatriot, Antonio Brugada: 'He blackened the ivory plaque and let fall on it a drop of water which, as it spread, lifted off part of the black ground and traced chance lines. Goya made use of these furrows and always brought out something original and unexpected. These little productions belong to the same family as *Los Caprichos*.'

During these last years in Bordeaux, Goya painted a number of still-life subjects, observed, according to Matheron, in the market-place and executed on his return home, 'in a hand's turn, between two cigarettes'. The only still-life paintings known today are from an earlier period (see Plate 33). A few genre subjects and some portraits of his friends complete the catalogue of his paintings. The genre scenes of the year before Goya's death – *The Milkmaid of Bordeaux* (Plate 48), the *Head of a Monk* and the *Head of a Nun* – are difficult to categorize. Like many of his earlier uncommissioned works, they seem to belong neither to genre proper, nor to religious painting, nor to portraiture. The portraits of Santiago Galos (1826, Barnes Collection, Philadelphia, PA), Juan de Muguiro (1827, Museo del Prado, Madrid), José Pío de Molina (1828, Reinhardt Collection, Wintherthur) are the most remarkable illustrations of the final development of his style. 'There again,' writes Matheron, who had seen weakness of touch and uncertainty of drawing in the still-life and

other late paintings, 'before the living model, a double *binocle* on his nose, he found himself again for a brief space.' The free handling of form and colour in these last paintings, the assurance with which they achieve their effect in terms of light and shade, without outline or detail and in a narrow range of tones, today make them among the most admired of Goya's works.

In 1792, nearly 40 years before he painted his last works, Goya had announced his credo: 'I shall give a proof to demonstrate with facts that there are no rules in painting and that the tyranny which obliges everyone, as if they were slaves, to study in the same way or to follow the same method is a great impediment to the young who practise this very difficult art, which comes closer to the divine than any other, since it makes known what God has created. Even those who have gone furthest in the matter can give few rules about the deep play of understanding that is needed, or say how it came about that they were sometimes more successful in a work executed with less care than in one on which they had spent most time. What a profound and impenetrable mystery is locked up in the imitation of divine nature, without which there is nothing good, not only in Painting (which has no other function than the exact imitation [of nature]) but also in the other sciences!' In his old age, Matheron records, Goya mocked the academicians and their methods of teaching – 'Always lines, never forms', he is reported to have said in one of his rare conversations about painting. 'But where do they find these lines in nature? Personally I only see forms that are lit up and forms that are not, planes which advance and planes which recede, relief and depth. My eye never sees outlines or particular features or details. I do not count the hairs in the beard of the man who passes by any more than the buttonholes on his jacket attract my notice. My brush should not see better than I do.' And again: 'In nature, colour does not exist any more than lines. There is only light and shadow. Give me a piece of charcoal and I will make you a picture. All painting is a matter of sacrifice and *parti-pris*.' The reduction of Goya's palette had come slowly and step by step with his abandonment of academic style. The brightly coloured and decorative tapestry cartoons, with which his career was launched, belong to another world and an earlier century.

It is the works of his maturity and old age, varied, penetrating, sombre, melancholy, violent and technically audacious, which made Goya's reputation as the greatest master of his age and the first of the moderns. Our last record of Goya's life are the letters to his son in which he expresses his joy at the prospect of a visit from his grandson and daughter-in-law and his impatience to see them. They arrived on 28 March, shortly before Goya wrote his last lines to his son: 'I can only say that such joy has made me a little indisposed and I am in bed.' A few days later he suffered a paralytic stroke and died on 16 April 1828.

Outline Biography

1746 Francisco José de Goya y Lucientes born 30 March, the son of a master gilder, at Fuendetodos, a small village near Saragossa in Aragon.

1760 Studies for a few years in Saragossa with José Luzán, a local artist who had trained in Naples.

1763 and 1766 Competes unsuccessfully for scholarships offered by the Royal Academy of San Fernando, Madrid.

1771 In Rome in April; submits a painting to a competition held by the Academy in Parma describing himself as a pupil of Francisco Bayeu; wins six votes and official commendation.

1771 That winter submits sketches for frescoes in the Cathedral of El Pilar, Saragossa.

1773 Marries Josefa Bayeu, sister of Francisco Bayeu.

1774 Summoned by Mengs to paint cartoons for tapestries to be woven at the Royal Factory of Santa Barbara, Madrid. Settles in Madrid.

1775-92 Occupied intermittently with tapestry cartoons.

1778 Publishes 16 etchings after paintings by Velázquez.

1780 Elected to membership of the Royal Academy of San Fernando.

1780-81 Returns to Saragossa to paint frescoes in the Cathedral of El Pilar.

1784 Birth of Goya's son Francisco Javier.

1785 Appointed Deputy Director of Painting in the Academy.

1786 Appointed Painter to the King (*Pintor del Rey*).

1789 Raised to the rank of Court Painter (*Pintor de Cámara*).

1792 Falls seriously ill during a journey to Andalusia and is left permanently deaf.

1793 Paints group of uncommissioned cabinet pictures during convalescence.

1795 Appointed Director of Painting in the Academy.

1797 Resigns Directorship for reasons of health.

1798 Fresco decorations in San Antonio de la Florida, Madrid.

1799 Announcement in February of the publication of *Los Caprichos*.

1799 Appointed First Court Painter (*Primer Pintor de Cámara*) in October, a position he held during the succeeding reigns.

1800 Portrait of *Charles IV and his Family*.

1803 Presents plates of *Los Caprichos* to the King in return for a pension for his son.

1804 Applies unsuccessfully to be made Director General of the Academy.

1808 Napoleonic invasion of Spain. Goya paints an equestrian portrait of Ferdinand VII; swears allegiance to the French King, Joseph Bonaparte.

1810 Dates some of the drawings for the *Desastres de la Guerra*.

1811 Awarded the Royal Order of Spain by Joseph Bonaparte.

1812 After the death of his wife in June an inventory is made of the contents of Goya's house in October; paints an equestrian portrait of the Duke of Wellington.

1814 The French expelled from Spain; restoration of Ferdinand VII; Goya paints *The Second of May* and *The Third of May* to commemorate the War of Independence.

1815 Summoned to appear before the Inquisition on account of the *Majas*.

1816 Publication of the *Tauromaquia*.

1819 Suffers serious illness; paints *The Last Communion of St Joseph of Calasanz*.

1820 Paints self-portrait with his doctor Arrieta, in gratitude for his recovery; makes his last appearance at the Academy to swear allegiance to the newly restored Constitution.

c.1820-23 Decorates his house, the Quinta del Sordo, with the 'Black Paintings'; etches the *Disparates* or *Proverbios*.

1823 After a liberal interlude the King restored to absolute power.

1824 Goya goes into hiding; applies for leave of absence to go to France; settles in Bordeaux after a visit to Paris.

1825 Goya continues to paint and draw and embarks on two new ventures: the *Bulls of Bordeaux* (lithographs) and a series of miniatures on ivory.

1826 Visits Madrid; resigns as First Court Painter and is given a pension.

1828 Dies in Bordeaux on 16 April, shortly after the arrival of his daughter-in-law and grandson.

Select Bibliography

The autobiographical notice of Goya published in the catalogue of the Prado Museum (1828), the biographies of Goya by his son Franciso Javier (1830) and his friend Valentín Carderera (1835), together with Goya's reports to the Academy on the study of art (1792) and the restoration of paintings (1801), were printed in English translation as appendices to the first edition of this book.

L. Matheron, *Goya*, Paris, 1858.

C. Yriarte, *Goya, sa biographie etc.*, Paris, 1867.

Conde de la Viñaza, *Goya: su tiempo, su vida, sus obras*, Madrid, 1887.

A. de Beruete y Moret, *Goya, pintor de retratos*, Madrid, 1916.

A. de Beruete y Moret, *Goya, composiciones y figuras*, Madrid, 1917.

A. L. Mayer, *Francisco de Goya*, English ed., London, 1924.

Calleja (ed.), *Goya: Colección de cuadros y dibujos precedida de su biografía y de un epistolario*, Madrid, 1924.

V. de Sambricio, *Tapices de Goya*, Madrid, 1946.

E. Lafuente Ferrari, *Antecedentes, coincidencias e influencias del arte de Goya*, Madrid, 1947.

F. D. Klingender, *Goya in the democratic tradition*, London, 1948; second ed., London, 1968.

X. Desparmet-FitzGerald, *L'oeuvre peint de Goya*, Paris, 1928-50.

F. J. Sánchez Cantón, *Vida y obras de Goya*, Madrid, 1951 (English ed. 1954).

J. López-Rey, *Goya's Caprichos*, Princeton, 1953.

F. Sánchez Cantón, *Museo del Prado: Los dibujos de Goya*, Madrid, 1954.

E. Lafuente Ferrari, *The frescoes in San Antonio de la Florida in Madrid: Historical and critical study*, New York, 1955.

J. Ezquerra del Bayo, *La Duquesa de Alba y Goya*, Madrid, 1959.

F. Sánchez Cantón, *Goya and the Black Paintings*, with an Appendix by X. de Salas, London, 1964.

T. Harris, *Goya: Engravings and Lithographs*, Oxford, 1964.

J. Gudiol, Goya, 1746-1828, *Biografía, estudio analítico y catálogo de sus pinturas*, Barcelona, 1970.

P. Gassier and J. Wilson, *The Life and Complete Work of Francisco Goya*, New York, 1971.

P. Gassier, *Francisco Goya: Drawings: The Complete Albums*, New York, 1973.

R. de Angelis, *L'opera pittorica completa di Goya*, Milan, 1974.

P. Gassier, *The Drawings of Goya: The Sketches, Studies and Individual Drawings*, London 1975.

N. Glendinning, *Goya and his Critics*, London, 1977.

J. Camón Aznar, *Goya*, Saragossa, 1980-82.

A. Canellas López (ed.), *Diplomatario de Francisco Goya*, Saragossa, 1981.

M. Agueda and X. de Salas, (ed.), *Francisco de Goya, Cartas a Martín Zapater*, Madrid, 1982.

Edith F. Helman, *Trasmundo de Goya*, second ed., Madrid, 1983.

I. Rose Wagner, *Manuel Godoy. Patrón de las artes y coleccionista*, PhD thesis, Madrid, Universidad Complutense, 1983.

P. Muller, *Goya's Black Paintings*, New York, 1984.

Goya Nuevas Visiones: Homenaje a Enrique Lafuente Ferrari, Madrid, 1987.

Goya and the Spirit of the Enlightenment, Catalogue of the exhibition, Madrid, Boston and New York, 1988-9.

E. Harris and D. Bull, *Goya's Majas at the National Gallery*, London, 1990.

J. Wilson-Bareau, *Goya. La Década de los Caprichos. Dibujos y aguafuertes*, Madrid, 1992.

N. Glendinning, *Goya. La Década de los Caprichos. Retratos 1792-1804*, Madrid, 1992.

J. Baticle, *Goya*, Paris, 1992.

Goya: Truth and Fantasy Cabinet Paintings, Sketches and Miniatures. Exhibition Madrid, London, Chicago, 1993-4. Catalogue by J. Wilson-Bareau.

J. Tomlinson, *Goya*, London, 1994.

List of illustrations

Colour Plates

1. The Snowstorm
 1786-7. Canvas, 275 x 293 cm. Museo del Prado, Madrid

2. The Injured Mason
 1786-7. Canvas, 268 x 110 cm. Museo del Prado, Madrid

3. The Fall (*La Caída*)
 1786-7. Canvas, 169 x 100 cm. Duke of Montellano, Madrid

4. The Greasy Pole (*La Cucaña*)
 1786-7. Canvas, 169 x 88 cm. Duke of Montellano, Madrid

5. The Meadow of San Isidro on his Feast Day
 1788. Canvas, 74 x 84 cm. Museo del Prado, Madrid

6. Blind Man's Buff
 1789. Canvas, 269 x 350 cm. Museo del Prado, Madrid

7. The Straw Manikin (*El Pelele*)
 1791-2. Canvas, 267 x 160 cm. Museo del Prado, Madrid

8. The Yard of a Madhouse
 1794. Tinplate, 43.8 x 31.7 cm. Meadows Museum, Southern Methodist University, Dallas, TX

9. Portrait of Francisco Bayeu
 c.1795. Canvas, 112 x 84 cm. Museo del Prado, Madrid

10. Portrait of the Duchess of Alba
 1797. Canvas, 210 x 148 cm. The Hispanic Society of America, New York

11. St Gregory
 c.1797. Canvas, 188 x 113 cm. Museo Romántico, Madrid

12. The Miracle of St Anthony
 1798. Fresco. Detail of the decoration of the cupola of the church of San Antonio de la Florida, Madrid

13. The Bewitched Man
 c.1798. Canvas, 42.5 x 30.8 cm. National Gallery, London

14. Portrait of Andrés del Peral
 1798. Panel, 95 x 65.7 cm. National Gallery, London

15. Portrait of Gaspar Melchor de Jovellanos
 1798. Canvas, 205 x 133 cm. Museo del Prado, Madrid

16. Charles IV and his Family
 c.1800. Canvas, 280 x 336 cm. Museo del Prado, Madrid

17. The Naked Maja (*La Maja Desnuda*)
 c.1799-1800. Canvas, 97 x 190 cm. Museo del Prado, Madrid

18. The Clothed Maja (*La Maja Vestida*)
 1800-3. Canvas, 97 x 190 cm. Museo del Prado, Madrid

19. Manuel Godoy, Duke of Alcudia, 'Prince of the Peace'
 1801. Canvas, 180 x 267 cm. Royal Academy of San Fernando, Madrid

20. Portrait of Antonia Zárate
 c.1805. Canvas, 103.5 x 81.9 cm. National Gallery of Ireland, Dublin

21. Portrait of a Lady with a Fan
 c.1806-7. Canvas, 103 x 83 cm. Musée du Louvre, Paris

22. Portrait of Victor Guye
 1810. Canvas, 104.5 x 83.5 cm. The National Gallery of Art, Washington, DC

23. Portrait of Mariano Goya, the Artist's Grandson
 c.1812-14. Panel, 59 x 47 cm. Duke of Albuquerque, Madrid

24. Allegory of the City of Madrid
 1810. Canvas, 260 x 195 cm. Museo Municipal, Madrid

25. A Woman Reading a Letter
c.1812-14. Canvas, 181 x 122 cm. Musée des
Beaux-Arts, Lille

26. Time and the Old Women
c.1810-12. Canvas, 181 x 125 cm. Musée des
Beaux-Arts, Lille

27. The Burial of the Sardine
c.1812-14. Panel, 82 x 60 cm. Royal Academy of
San Fernando, Madrid

28. A Procession of Flagellants
c.1812-14. Panel, 46 x 73 cm. Royal Academy of
San Fernando, Madrid

29. A Village Bullfight
c.1812-14. Panel, 45 x 72 cm. Royal Academy of
San Fernando, Madrid

30. The Madhouse
c.1812-14. Panel, 45 x 72 cm. Royal Academy of
San Fernando, Madrid

31. A Prison Scene
c.1810-14. Zinc, 42.9 x 31.7 cm. Bowes Museum,
Barnard Castle

32. The Colossus
c.1810-12. Canvas, 116 x 105 cm. Museo del
Prado, Madrid

33. Still Life: A Butcher's Counter
c.1810-12. Canvas, 45 x 62 cm. Musée du Louvre,
Paris

34. Portrait of the Duke of Wellington
1812. Panel, 64 x 52 cm. National Gallery, London

35. Portrait of Ferdinand VII
c.1814. Canvas, 207 x 144 cm. Museo del Prado,
Madrid

36. The Second of May, 1808: The Charge
of the Mamelukes
1814. Canvas, 266 x 345 cm. Museo del Prado,
Madrid

37. The Third of May, 1808: The Execution
of the Defenders of Madrid
1814. Canvas, 266 x 345 cm. Museo del Prado,
Madrid

38. Self-portrait
1815. Panel, 51 x 46 cm. Royal Academy of San
Fernando, Madrid

39. The Forge
c.1819. Canvas, 191 x 121 cm. Frick Collection,
New York

40. Portrait of Juan Antonio Cuervo
1819. Canvas, 120 x 87 cm. Museum of Art,
Cleveland, OH

41. Portrait of Ramón Satué
1823(?). Canvas, 104 x 81.3 cm. Rijksmuseum,
Amsterdam

42. The Last Communion of St Joseph of
Calasanz
1819. Canvas, 250 x 180 cm. Church of the
Escuelas Pías de San Antón, Madrid

43. Self-portrait with Dr Arrieta
1820. Canvas, 117 x 79 cm. Institute of Arts,
Minneapolis, MN

44. Tío Paquete
c.1820. Canvas, 39.1 x 31.1 cm. Museo Thyssen-
Bornemisza, Madrid

45. A Pilgrimage to San Isidro
c.1820-3. Canvas, 140 x 438 cm. Museo del Prado,
Madrid

46. Saturn Devouring One of his Children
c.1820-3. Canvas, 146 x 83 cm. Museo del Prado,
Madrid

47. St Peter Repentant
c.1823-5. Canvas, 29 x 25.5 cm. The Phillips
Collection, Washington, DC

48. The Milkmaid of Bordeaux
c.1827. Canvas, 74 x 68 cm. Museo del Prado,
Madrid

Text Illustrations

1. Goya's home in Fuendetodos

2. Christ on the Cross
 1780. Canvas, 255 x 153 cm. Museo del Prado,
 Madrid

3. Martín Zapater Reading a
 Letter from Goya
 1790. Canvas, 83 x 65 cm. Private collection

4. Charles III in Hunting Costume
 c.1786-8. Canvas, 206 x 130 cm. Collection Fernán-
 Núñez, Madrid

5. Charles IV on Horseback
 1799. Canvas, 336 x 282 cm. Museo del Prado,
 Madrid

6. Self-portrait
 c.1785-90. The artist at his easel, wearing his studio
 hat. Canvas, 42 x 28 cm. Royal Academy of San
 Fernando, Madrid

7. Self-portrait Drawing at a Window by
 Rembrandt van Rijn
 1648. Etching, 15.7 x 12.8 cm

8. Self-portrait
 1799. From the series *Los Caprichos*, Plate 1.
 Etching and aquatint, 21 x 15.2 cm

9. Portrait of Javier Goya, the Artist's Son
 1824. Black chalk, 9 x 8 cm. Lehman Collection,
 New York

10. Portrait of Goya by Vicente López
 1826. Museo del Prado, Madrid

11. 'I am Still Learning' ('*Aún aprendo*')
 1824-8. Black chalk, 19.5 x 15 cm. Museo
 del Prado, Madrid

12. Young Woman, Half-naked, Leaning
 against Rocks
 1824-5. Miniature on ivory, 8.8 x 8.6 cm. Museum
 of Fine Arts, Boston, MA

Comparative Figures

13. **The Snowstorm**
 1786. Sketch for tapestry cartoon. Canvas, 31.7 x 33 cm. Private collection

14. **The Hermitage of San Isidro on his Feast Day**
 1788. Canvas, 42 x 44 cm. Museo del Prado, Madrid

15. **Feminine Folly (*Disparate Femenino*)**
 c.1816-23. From the series *Los Disparates* or *Proverbios*, Plate 1. Etching and aquatint, 24 x 35 cm

16. **A Lunatic behind Bars**
 1824-8. Black chalk, 19.3 x 14.5 cm. The Woodward Collection, New York

17. **The Duchess of Alba Tearing her Hair**
 1796-7. Indian ink wash, 17.1 x 10.1 cm. Biblioteca Nacional, Madrid

18. **St Isidore of Seville by Bartolomé Esteban Murillo**
 1655. Canvas, 193 x 165 cm. Seville Cathedral Sacristy

19. **Church of San Antonio de la Florida. Interior, looking up into the cupola**

20. **The Sleep of Reason Produces Monsters (*El sueño de la razón produce monstruos*)**
 1799. From the series *Los Caprichos*, Plate 43. Etching and aquatint, 21.6 x 15.2 cm

21. **Francisco de Saavedra**
 1798. Canvas, 196 x 118 cm. Courtauld Institute Galleries, London

22. ***Las Meninas*, after Diego Velázquez**
 c.1778. Etching with aquatint. British Museum, London

23. **Self-portrait, detail of *Charles IV and his Family***

24. **The Toilet of Venus ('The Rokeby Venus') by Diego Velázquez**
 1649-51. Canvas, 122.7 x 177 cm. National Gallery, London

25. **Naked Woman Holding a Mirror**
 1796-7. Indian ink wash, 23.4 x 14.5 cm. Biblioteca Nacional, Madrid

26. **Birds of a Feather (*Tal para qual*)**
 1799. From the series *Los Caprichos*, Plate 5. Etching and aquatint, 20 x 15.1 cm

27. **Antonia Zárate**
 c.1805. Canvas, 71 x 58 cm. Formerly Howard B. George Collection, Washington, DC

28. **Gumersinda Goicoechea, Goya's daughter-in-law**
 1805. Black chalk, 11 x 8.2 cm. Carderera Collection, Madrid

29. **Until Death (*Hasta la Muerte*)**
 1799. From the series *Los Caprichos*, Plate 55. Etching and aquatint, 21.8 x 15.2 cm

30. **Burial of the Sardine**
 c.1813-14. Pen and sepia ink, 22 x 18 cm. Museo del Prado, Madrid

31. **Holy Week in Spain in Times Past (*Semana Santa en Tiempo Pasado en España*)**
 c.1820-4. Black chalk, 19.1 x 14.6 cm. National Gallery of Canada, Ottawa

32. **Spanish Entertainment (*Dibersion de España*)**
 1825. One of the four *Bulls of Bordeaux*. Lithograph, 30 x 41 cm. Signed '*Goya*'

33. **Chained Prisoner**
 c.1806-12. Indian ink wash, 21.8 x 15.1 cm. Musée Bonnat, Bayonne

34. **The Captivity is as Barbarous as the Crime (*Tan Barbara la Seguridad como el Delito*)**
 c.1810-20. Etching and burin, 11 x 8.5 cm

35. **The Colossus**
 c.1810-18. Goya's only mezzotint engraving, 28.5 x 21 cm

36. The Worst is to Beg (*Lo Peor es Pedir*)
c.1812-15. From the series *Los Desastres de la Guerra*, Plate 55. Etching and lavis, 15.5 x 20.5 cm

37. The Duke of Wellington
Red chalk over pencil, 23.2 x 17.5 cm. British Museum, London

38. The Execution of Maximilian by Edouard Manet
1868. Lithograph, 33.3 x 43.3 cm

39. Three Men Digging
1819. Sepia wash, 20.6 x 14.3 cm. Metropolitan Museum of Art, New York

40. The Agony in the Garden
1819. Panel, 47 x 35 cm. College of the Escuelas Pías de San Antón, Madrid

41. Of What Ill Will he Die?
(*De que mal morirá?*)
1799. From the series *Los Caprichos*, Plate 40. Etching and aquatint, 21.7 x 15.1 cm

1

The Snowstorm

1786-7. Canvas, 275 x 293 cm. Museo del Prado, Madrid

This was one of a series of tapestry cartoons (see also Plate 2), painted shortly after Goya's appointment as Painter to the King (*Pintor del Rey*) in 1786. The sketches were submitted to the King at the Escorial in the autumn of that year. The sketch for *The Snowstorm* (Fig. 13) was sold to the Duke of Osuna in 1799 as one of the *Four Seasons*. The cartoon and three others, painted at the same time for tapestries to decorate the dining-room in the Palace of El Pardo, may have been intended as representations of the *Seasons*. If so, Goya's *Winter* is unconventional in portraying men enduring the rigours of a snowstorm rather than enjoying the pleasures or comforts of the season.

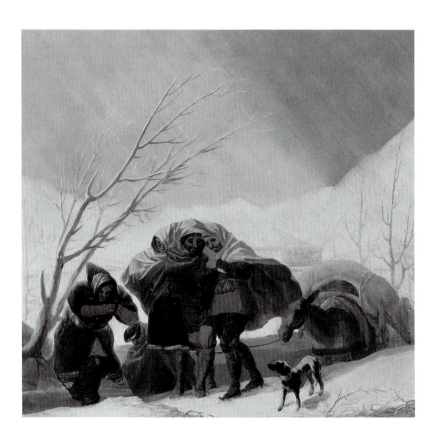

Fig. 13
The Snowstorm
1786. Sketch for
tapestry cartoon.
Canvas, 31.7 x 33 cm.
Private collection

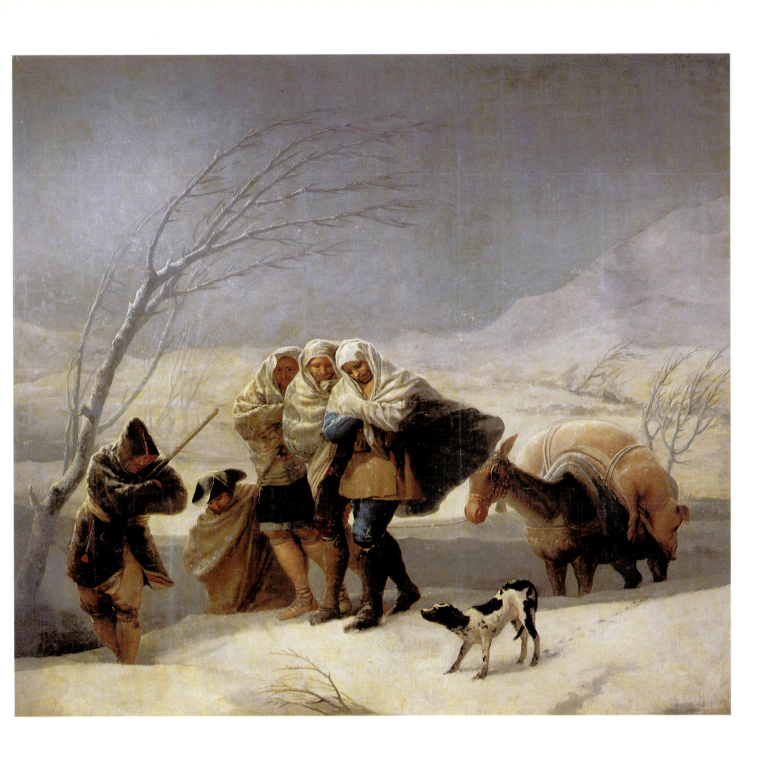

2 The Injured Mason

1786-7. Canvas, 268 x 110 cm. Museo del Prado, Madrid

This belongs to the same series of cartoons as *The Snowstorm* (Plate 1) and was also the model for a tapestry to decorate the dining-room in the Palace of El Pardo. The scene of an accident is even more unusual as palace decoration than *The Snowstorm* or *Poor Children at the Fountain*, another cartoon in the series. The dramatic subject has been related (by Edith Helman) to an edict of Charles III, first published in 1778, concerning building construction and specifying how scaffolding should be erected 'to avoid accidents and the death of workmen'. In the sketch for the cartoon (also in the Prado), purchased by the Duke of Osuna in 1799, the two men carrying the 'injured' mason have jovial expressions, which have given rise to its modern title *The Drunken Mason*. Many years later Goya returned to the subject of a building site with elaborate scaffolding, in a drawing now in the Metropolitan Museum.

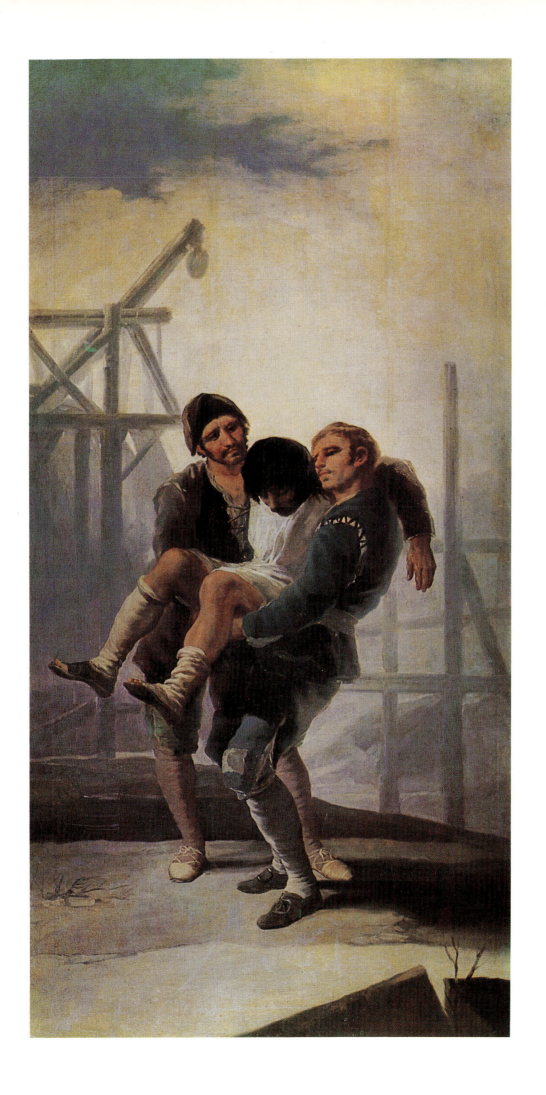

3 The Fall (La Caída)

1786-7. Canvas, 169 x 100 cm. Duke of Montellano, Madrid

La Caída and *La Cucaña* (Plate 4) belong to a series of seven paintings of 'country subjects' made to decorate the large gallery in the Duchess of Osuna's apartment in the Alameda Palace, the Osuna country residence outside Madrid known as El Capricho. The paintings were delivered on 22 April 1787. *La Caída* is described in Goya's account for the paintings submitted on 12 May 1787: 'an excursion in hilly country, with a woman in a faint after a fall from an ass; she is assisted by an abbot and another man who support her in their arms; two other women mounted on asses [and] expressing emotion and another figure of a servant form the main group and others who had fallen behind are seen in the distance, and a landscape to correspond.'

Though on a smaller scale, this series of decorative paintings is similar in style and character to the tapestry cartoons; but unlike the tapestry cartoons it includes some scenes, such as *La Caída*, which appear to represent actual occurrences. It has been suggested that the fainting woman in *La Caída* is the Duchess of Osuna, that the figure supporting her is Goya and that the mounted woman weeping is the Duchess of Alba.

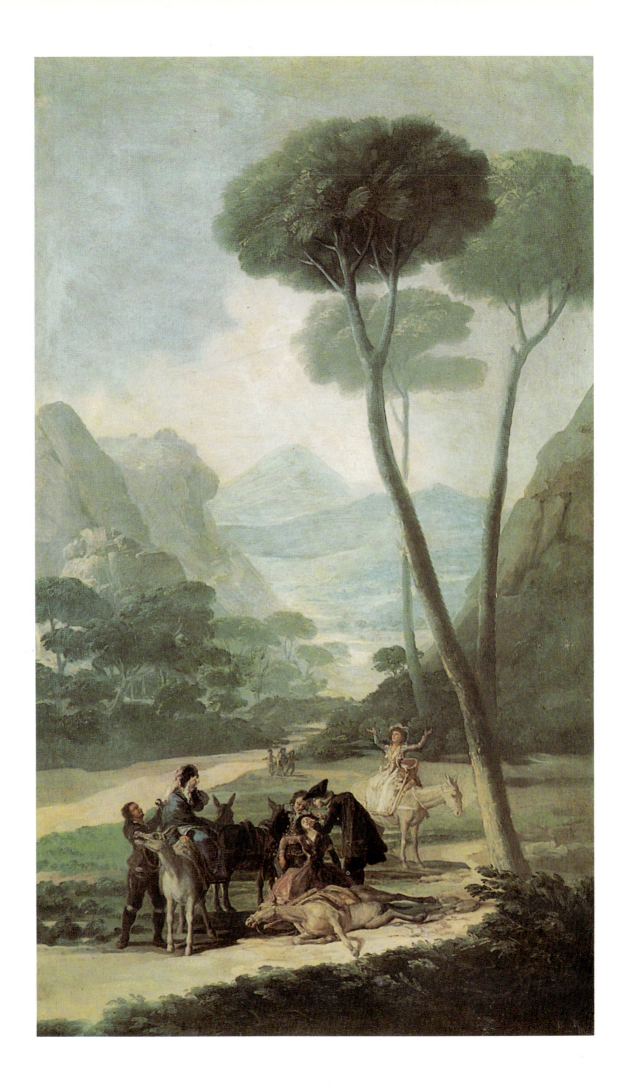

The Greasy Pole (La Cucaña)

1786-7. Canvas, 169 x 88 cm. Duke of Montellano, Madrid

Painted at the same time as *La Caída* (Plate 3), *La Cucaña* is described in Goya's account: 'a maypole, as in a village square, with boys climbing up it to win a prize of chickens and *roscas* [ring-shaped biscuits] that are hanging on top, and several people watching, with a background to correspond'. The small scale of the figures in relation to the background is a feature of all the paintings of this series. Later, in 1799, the Duke acquired seven of the sketches for tapestry cartoons that were never executed, to add to the collection of 'country subjects' painted by Goya for his country residence (see Plate 3). Goya also painted portraits of the Duke and Duchess and a family group with their children (Museo del Prado, Madrid).

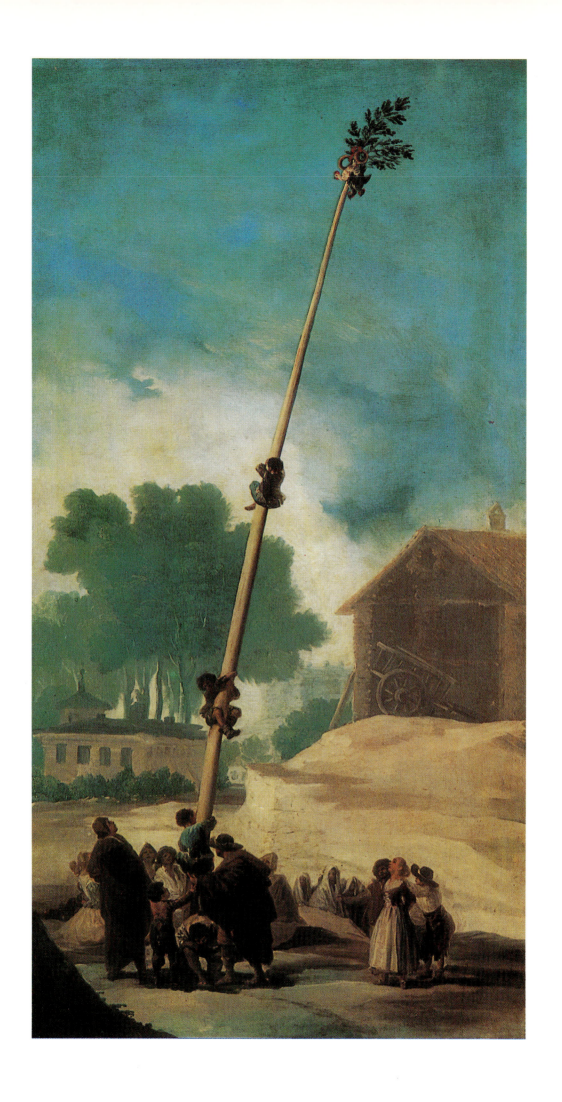

1788. Canvas, 74 x 84 cm. Museo del Prado, Madrid

Fig. 14
The Hermitage
of San Isidro on his
Feast Day
1788. Canvas, 42 x 44 cm.
Museo del Prado, Madrid

This was one of the sketches for a tapestry cartoon that was never executed, due to the death of Charles III, who had commissioned them. It was among the sketches sold to the Duke of Osuna in 1799. The scene represents the most popular festival in the Madrid calendar, which is still celebrated on 15 May, the feast day of the city's patron saint, Isidore the Labourer. In a letter to his friend Zapater in Saragossa, Goya wrote of the difficulties of such a subject especially as he had to finish this painting by the saint's day 'with all the bustle of the court'. It is in fact a rare example of a landscape by Goya, taken from the far side of the Manzanares River with the city's landmarks on the horizon, and in the foreground the crowds amusing themselves as at a fair, the pilgrims hard to distinguish among the animated crowds. Goya's viewpoint must have been the Hermitage of San Isidro, the goal of the pilgrimage (Fig. 14). The building in Goya's painting (also designed as a sketch for a tapestry cartoon), is still preserved, marking the spot where the saint struck a well of water with healing powers. On a tiny scale, Goya has included the pilgrims lining up to enter the church, a picnic scene and a group at the miraculous well. Many years later Goya was to decorate the walls of his country house, the Quinta del Sordo, built not far from the Hermitage, with a nightmare vision of *A Pilgrimage to San Isidro* (Plate 45). In his *Handbook* (1845), Richard Ford described the pilgrimage as it was in his day: 'It is a truly Spanish and charming scene, far surpassing our Easter Monday at Greenwich, not merely in fun but piety, for this is a religious pilgrimage; thus their wise church renders their acts of devotion sources of enjoyment to its believers.'

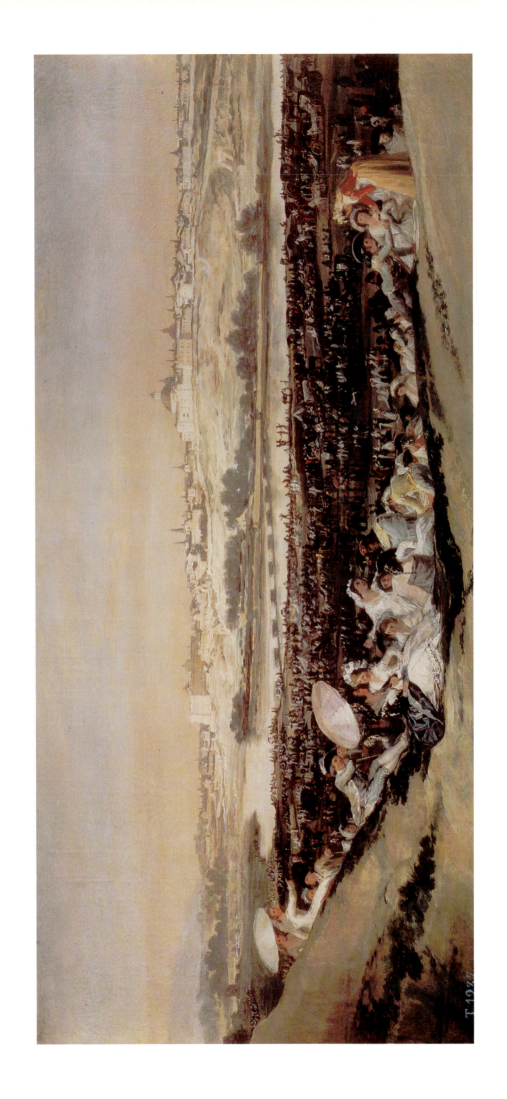

Blind Man's Buff

1789. Canvas, 269 x 350 cm. Museo del Prado, Madrid

In 1788 Goya was engaged on the sketches for cartoons for tapestries to decorate the bedroom of the Infantes in the Palace of El Pardo. On 31 May 1788 he wrote to his friend Zapater telling him that he had been ordered to complete the sketches 'in time for the Court's arrival...I am working with great determination and vexation as there is little time and they have to be seen by the King, Princes, etc....I can neither sleep nor rest until I have finished the job and don't call it living, this life that I live...' *Blind Man's Buff* is the only finished cartoon made from these sketches (the sketch for it is in the Prado), probably because of the death of Charles III and the subsequent withdrawal of tapestries from El Pardo. Goya has reverted to a conventional composition (compared with Plates 1 and 2) with marionette-like figures for the representation of a society pastime – a pastime described by Lady Holland in her *Spanish Journal* (1803) as one of 'the pleasures of the nursery offered to grown-up ladies and gentlemen'.

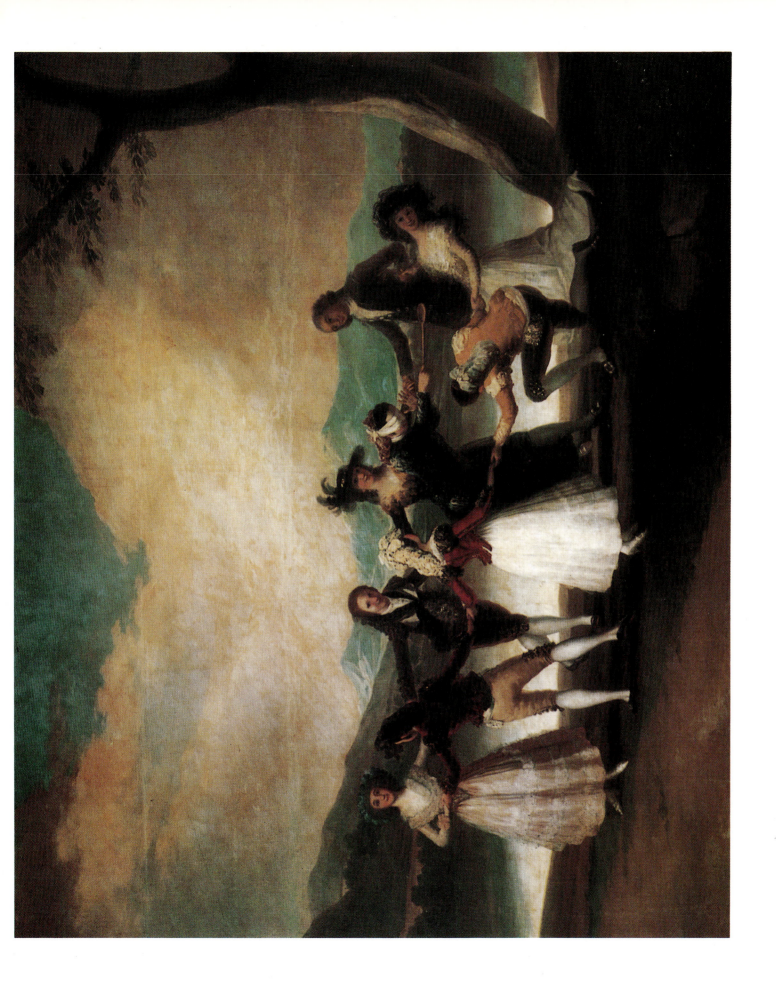

The Straw Manikin (El Pelele)

1791-2. Canvas, 267 x 160 cm. Museo del Prado, Madrid

This belongs to Goya's last suite of tapestry cartoons, the only series made for Charles IV after Goya's appointment as Court Painter. The tapestries were to decorate one of the apartments in the Escorial and the subjects, chosen by the King, were to be 'rural and jocose'. Goya had delayed making the sketches as he objected to receiving his instructions from Maella instead of from the Lord Chamberlain. He eventually submitted, since he did not, as he said, want to appear proud. After the naturalism of some of the earlier cartoons, the stiffness of the figures and their artificial expressions come as a surprise. The human figures are as puppet-like as the straw manikin they are tossing in a blanket. Some of the subjects of the tapestry cartoons that Lady Holland described as 'the pleasures of the nursery' enjoyed by grown-ups (see Plate 6) were to be transformed in Goya's late lithographs into dark, grotesque parodies (see Fig. 15).

Fig. 15
Feminine Folly
(*Disparate Femenino*)
c.1816-23. From the
series *Los Disparates*
or *Proverbios*, Plate 1.
Etching and aquatint,
24 x 35 cm

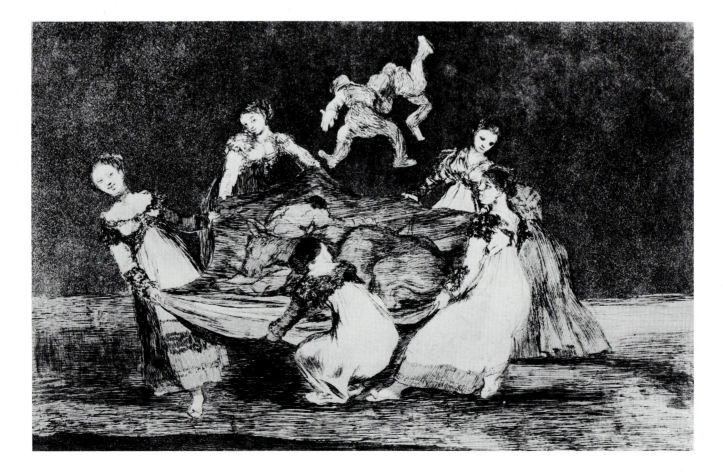

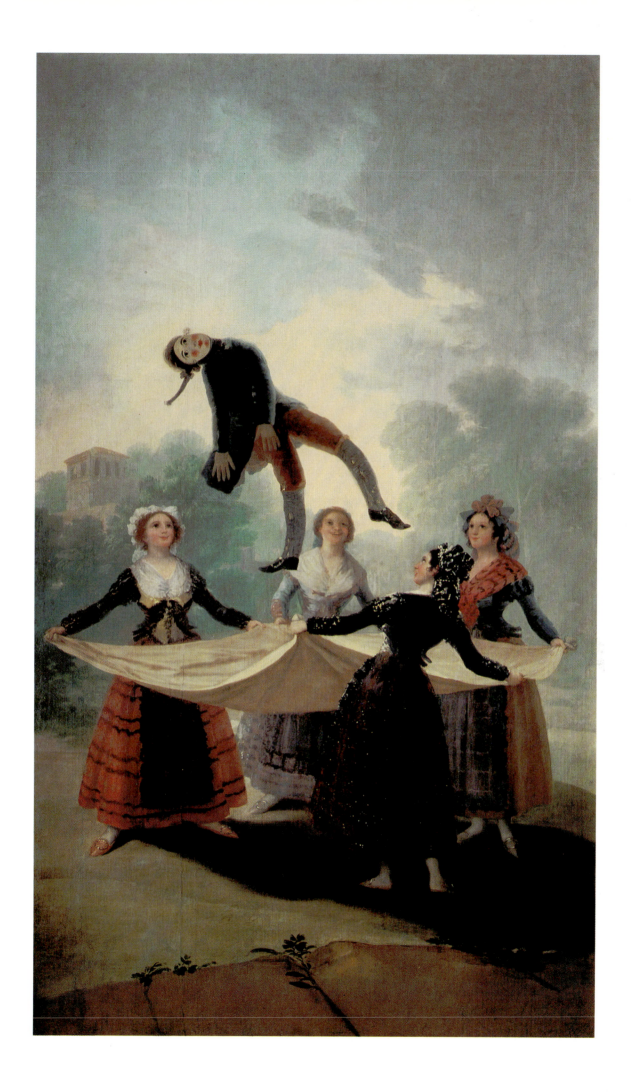

The Yard of a Madhouse

1794. Tinplate, 43.8 x 31.7 cm. Meadows Museum, Southern Methodist University, Dallas, TX

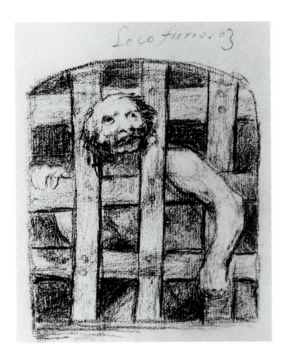

Fig. 16
A Lunatic behind
Bars
1824-8. Black chalk, 19.3 x
14.5 cm. The Woodward
Collection, New York
Inscribed '*Loco furioso*'
('Raging lunatic')

While he was recovering from the serious illness that left him totally deaf, Goya occupied himself with a series of 'cabinet' paintings which he sent to the Academy and which won approval as scenes of 'national pastimes'. A few days later, he followed these with a twelfth painting of a very different character, which he described in detail in a letter to the Director. It was a scene, he wrote, that he witnessed in Saragossa: 'the yard of a madhouse and two naked madmen fighting, with the man in charge beating them, and the others wearing sacks [or straitjackets]'. There was no need to worry about placing it quickly, he added, as 'I am aware of the difficulties of the subject'. The rediscovery of this picture in 1967 (Desparmet-FitzGerald) provided a touchstone for the identification of the rest of the set of cabinet pictures that Goya had sent to the Academy which are now considered to include subjects such as a *Shipwreck* and a *Fire* – hardly to be described as national pastimes – as well as *Strolling Players*, and possibly a group of *Bullfight* scenes. *The Madhouse* and other small paintings now in the Academy, once thought to have been among the scenes of so-called national pastimes (Plates 27-30) are now generally attributed to a considerably later date, for stylistic reasons. *The Yard of a Madhouse* is one of many scenes Goya recorded that he had actually witnessed, among them some of the war scenes in the *Desastres* (with the titles 'I saw this' and 'this too'). Many of his etchings and drawings testify to his concern for the plight of lunatics and prisoners throughout his life. See, for instance, the drawing of a madman behind bars made in Bordeaux (Fig. 16).

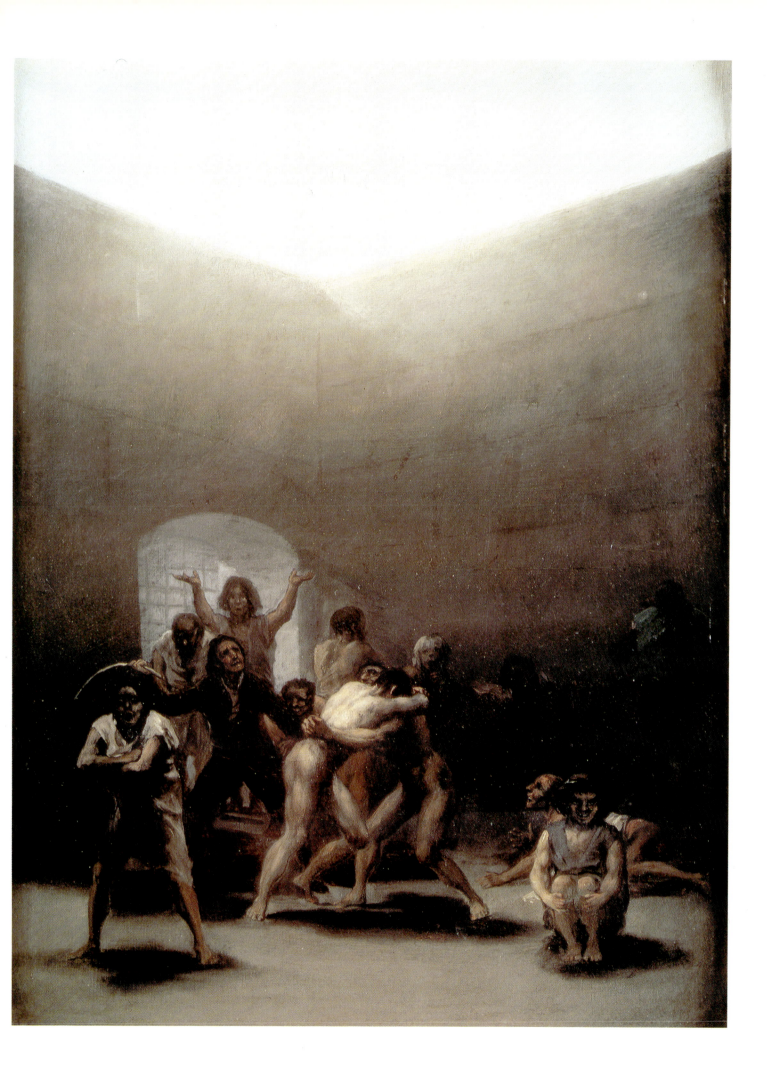

Portrait of Francisco Bayeu

c.1795. Canvas, 112 x 84 cm. Museo del Prado, Madrid

Goya's portrait of his brother-in-law and former teacher, whom he suc-
ceeded as Director of the Academy, was probably painted after Bayeu's
death in August 1795. It was unfinished when it was exhibited in the
Academy of San Fernando later in the same month. Although this portrait
is based on a self-portrait by Bayeu it has all the appearance of a study
from life. The predominance of grey and silvery tones is characteristic of a
group of Goya's portraits dating from the last years of the eighteenth
century. An earlier portrait of Bayeu (1786) by Goya is in the Museo San
Pío V, Valencia.

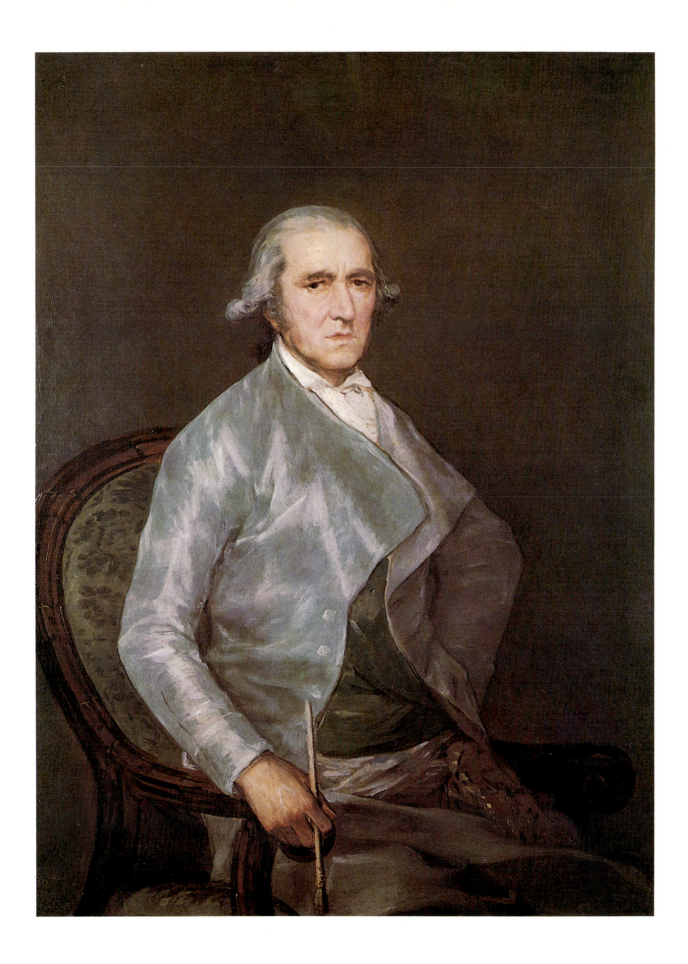

1797. Canvas, 210 x 148 cm. The Hispanic Society of America, New York
Signed '*Solo Goya/1797*'; inscribed (on the rings) '*Alba/Goya*'

Fig. 17
The Duchess of Alba
Tearing her Hair
1796-7. Indian ink wash,
17.1 x 10.1 cm. Biblioteca
Nacional, Madrid

The thirteenth Duchess of Alba was born in 1762, widowed in 1796 and died in 1802 in mysterious circumstances, which gave rise to the rumour that she was poisoned. She was a prominent figure in Madrid society; according to Lady Holland she was 'outstanding for her beauty, popularity, charm, riches and rank', and the poet Arjona acclaimed her as 'the new Venus of Spain'. Goya's relations with the Duchess were such that they have led to the suggestion that she posed for *La Maja Desnuda* (Plate 17). He stayed with her at her Andalusian estate in Sanlúcar after her husband's death and made several drawings of scenes in the domestic life of the Duchess and her household (see Fig. 17). She is also recognizable in several plates of *Los Caprichos* and in one unpublished etching, which seems to record an estrangement from the artist. In a letter to a friend (dated 1800), Goya describes a visit from the Duchess 'who came into my studio for me to paint her face and went out with it done for certainly I would rather do that than paint on canvas'. The present portrait was almost certainly painted during Goya's stay at Sanlúcar and remained in his possession. The name *Alba* on the ring on the Duchess's third finger and *Goya* on that on the downward-pointing index finger are in themselves evidence of Goya's intimacy with his sitter. The inscription on the ground at the Duchess's feet, to which her finger points (only uncovered in modern times), reads *Solo Goya*, the word *solo* ('only') strengthening the asumption that they were lovers. The stiff figure with its expressionless face is, however, more like the puppet-like figures of the tapestry cartoons than a portrait of a familiar sitter.

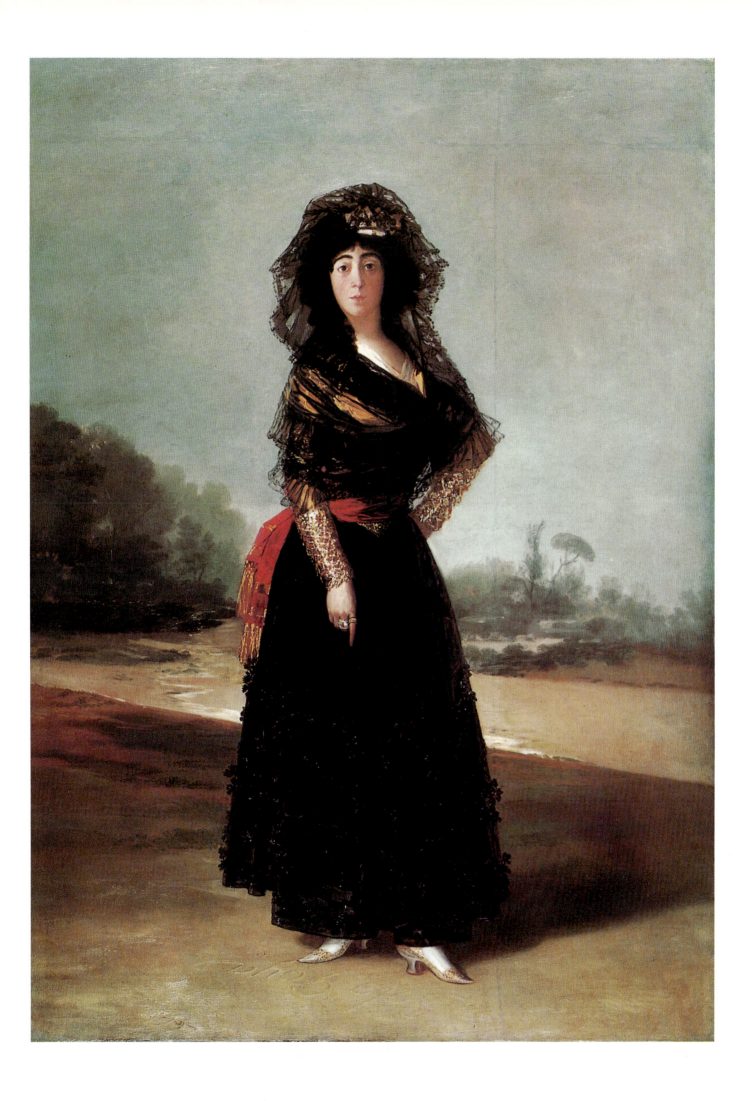

St Gregory

c.1797. Canvas, 188 x 113 cm. Museo Romántico, Madrid

This belongs to a series of representations of the four Doctors of the Church, of which the *St Augustine* and *St Ambrose* are also extant. They are not documented but are reasonably assumed to have been painted after Goya's visit to Andalusia in 1796-7 both on stylistic grounds and because of their resemblance to Murillo's seated figures of *St Isidore* (Fig. 18) and *St Leander* in Seville Cathedral. In style and colour they also reflect Goya's earlier studies of Tiepolo. Goya's *St Gregory*, seated on a platform like Murillo's saints, is a monumental figure in an undefined space, without décor or attributes other than the large book and papal tiara to identify him as the pope said to have left the greatest number of writings.

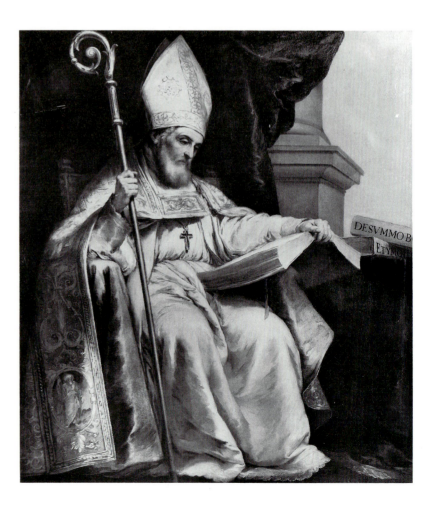

Fig. 18
**St Isidore of Seville
by Bartolomé Esteban
Murillo**
1655. Canvas, 193 x 165
cm. Seville Cathedral
Sacristy

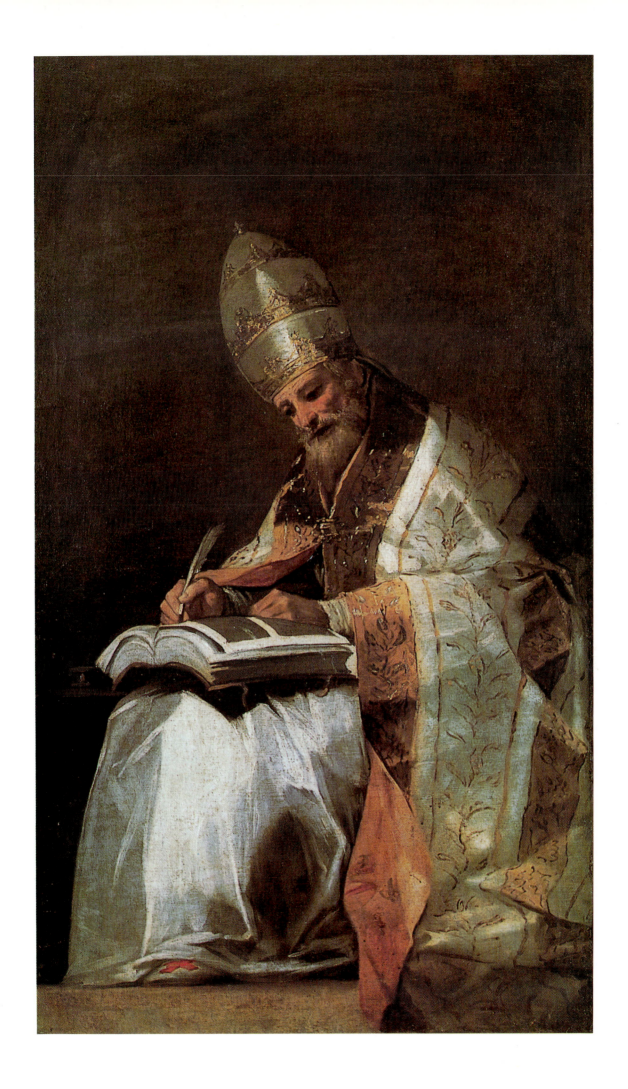

1798. Fresco. Detail of the decoration of the cupola of the church of San Antonio de la Florida, Madrid (see Fig. 19)

Fig. 19
Church of San
Antonio de la Florida.
Interior, looking up
into the cupola

Behind the painted railing surrounding the cupola, Saint Anthony, in the presence of a Lisbon crowd, brings back to life a murdered man in order to establish his father's innocence of the crime.

The church of San Antonio, a small neo-classical building on the outskirts of Madrid, was a royal chapel completed in 1798. The only document referring to Goya's decorations is an account for materials, 'for the work in the chapel of San Antonio de la Florida, which he carried out at His Majesty's bidding in this year, 1798'. The account, dated 20 December, covers the period between June and October and includes the cost of a carriage to take Goya to and from the church every day from 1 August until the completion of the work. The decoration of the cupola, apse, lunettes and pendentives, executed in fresco with added touches of tempera, is unprecedented in Goya's oeuvre for the boldness and individuality of its style. The placing of the principal scene of the miracle on the walls of the cupola – usually occupied by a representation of heaven – is unconventional, like the decoration of the walls below with female angels and painted curtains. The effect of the whole is almost that of a secular decoration, strong in colour and free in handling. Many years after his burial in Bordeaux, Goya's remains were taken back to Spain and since 1929 they have been entombed in this church.

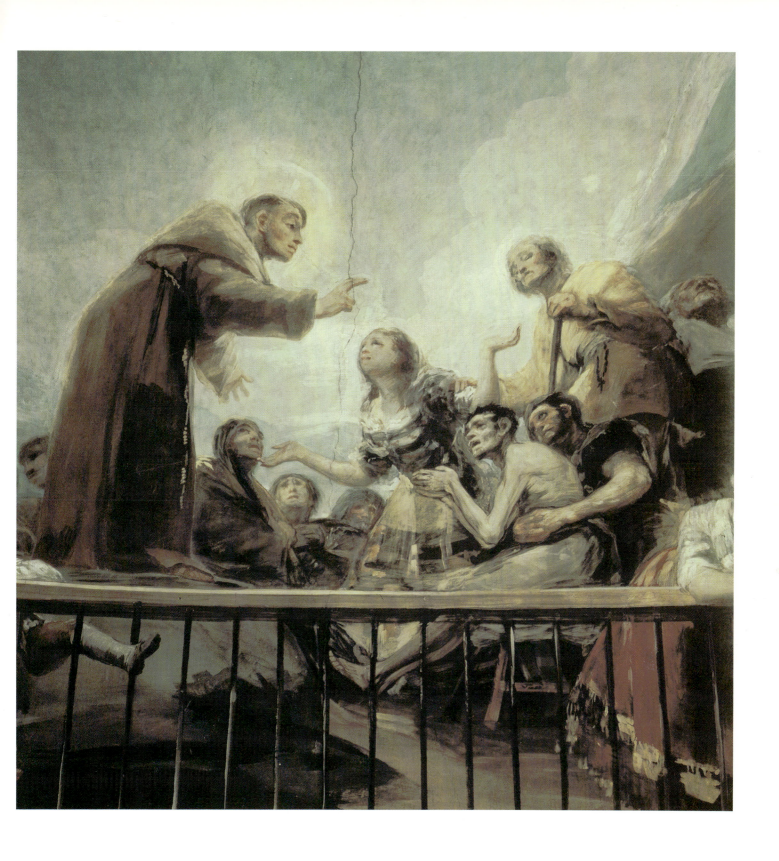

c.1798. Canvas, 42.5 x 30.8 cm. National Gallery, London

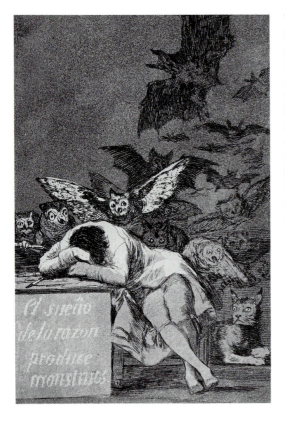

Fig. 20
The Sleep of Reason
Produces Monsters
(*El sueño de la razón
produce monstruos*)
1799. From the series
Los Caprichos, Plate 43.
Etching and aquatint,
21.6 x 15.2 cm

The inscription: LAM/DESCO (*Lámpara descomunal*, 'extraordinary lamp') identifies the subject as a scene from *El hechizado por fuerza* ('The man bewitched by force'), a play by Antonio de Zamora. The protagonist, Don Claudio, is led to believe that he is bewitched and that his life depends on keeping a lamp alight. The play was first performed in 1698 and reprinted several times, including 1795, shortly before Goya's painting. Goya has represented the scene as a theatrical performance, on a stage with the dancing donkeys as a backcloth (in the play they are described as paintings on a wall). The goat that appears to hold a lamp is no more than a stage property but the fear that it inspires in Don Claudio is portrayed with dramatic realism. This was one of six pictures of witches and devils painted by Goya for the Alameda of the Duke and Duchess of Osuna and paid for in 1798. The subjects are similar to scenes of witchcraft in *Los Caprichos* on which Goya was working at this time.

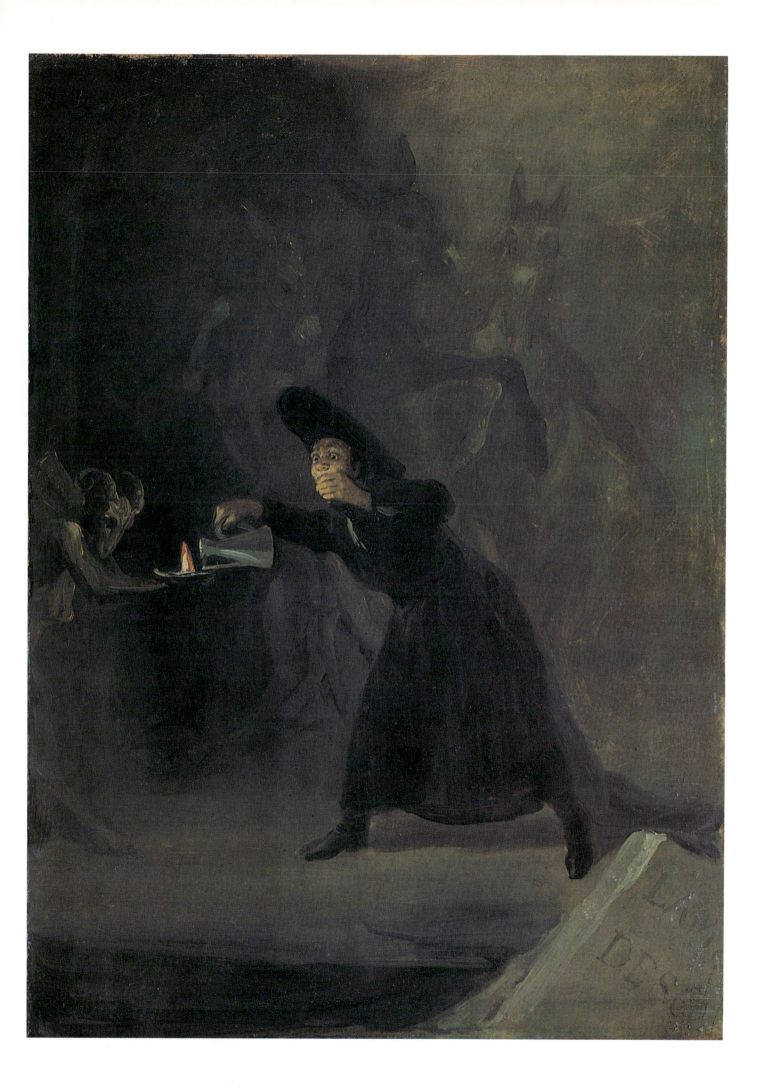

Portrait of Andrés del Peral

1798. Panel, 95 x 65.7 cm. National Gallery, London

According to a modern label on the back of the picture, the sitter was a doctor of law, and financial representative of the Spanish government in Paris at the end of the eighteenth century. He is known to have been a collector and to have owned a number of paintings by Goya. When the portrait of Peral was exhibited in the Academy of San Fernando in Madrid it was the subject of enthusiastic praise from an anonymous writer in the *Diario de Madrid* (17 August 1798): 'The portrait of don Andrés del Peral executed by the incomparable Goya would by itself be sufficient to recommend to posterity the whole of an Academy, the whole of a nation, the whole of the present age: such is the correctness of drawing, the taste in colour, the freedom, the understanding of chiaroscuro, in short, so great is the knowledge with which this Professor carries out his work.' It is interesting to find such fulsome appreciation of a painting which in fact defies the rules of 'correctness of drawing'. His friend Carderera was more discerning when he commented that Goya 'had such care and love for the grand effect of a picture that he usually put the last touches on by night with artificial light, at times taking little account of whether the drawing was more or less accurate'.

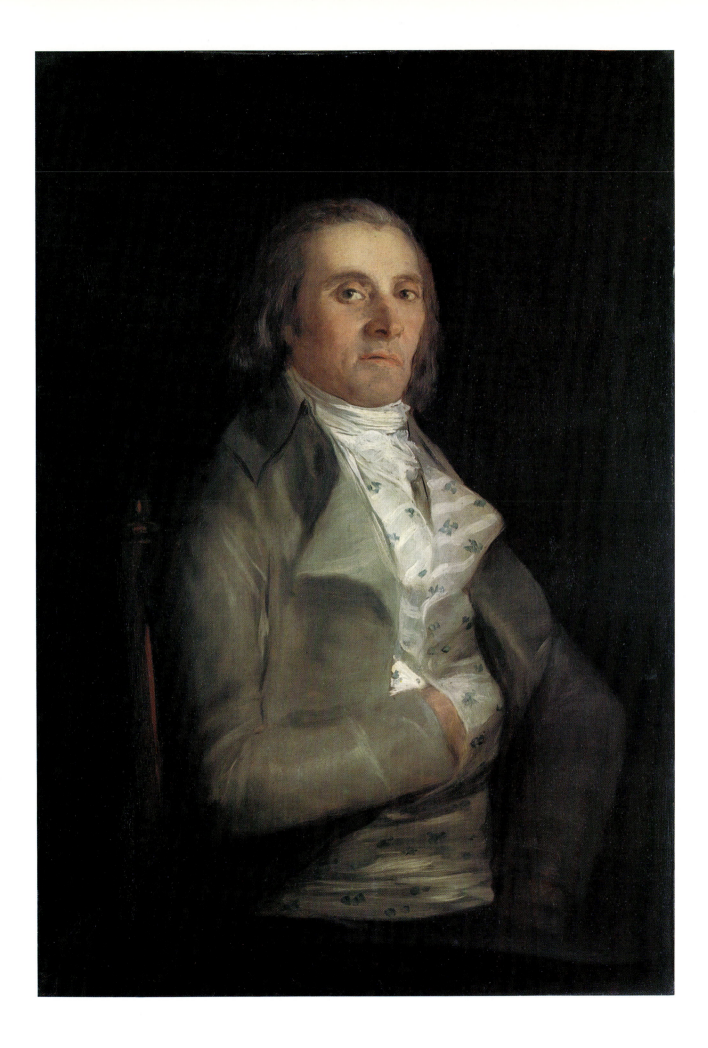

1798. Canvas, 205 x 133 cm. Museo del Prado, Madrid
Signed '*Jovellanos por Goya*'

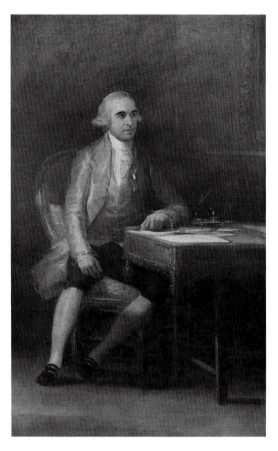

Fig. 21
Francisco de Saavedra
1798. Canvas, 196 x 118
cm. Courtauld Institute
Galleries, London
Signed '*Savedra [sic]
por Goya*'

Goya painted this grand portrait of his friend and patron, the learned writer and liberal statesman, at the time of his appointment as Minister of Grace and Justice. The portrait was painted while the court was at Aranjuez. On his return, Goya wrote with pride of the friendly behaviour of this eminent Minister to his friend, Martín Zapater in Saragossa in a letter (undated but apparently written in Madrid on 27 March 1798): 'The day before yesterday I arrived from Aranjuez and therefore did not reply sooner. The Minister surpassed himself in attentions to me, taking me with him for drives in his carriage and showing me the greatest possible expressions of friendship. He allowed me to eat with my cloak on because it was very cold and he learned to speak with hand-signs and stopped eating in order to speak to me. He wanted me to stay on until Easter and do a portrait of Saavedra (who is his friend) and I would have been pleased to do so but I had no canvas or change of shirt and left him displeased and came away.'

Not long afterwards Goya painted a portrait of Francisco de Saavedra, Minister of Finance, after he succeeded Godoy as Secretary of State (March 1798), in similar pose (Fig. 21). Heroes of a brief liberal interlude, both ministers were soon to be relieved of their posts, victims of Godoy: Jovellanos to become a political prisoner in Mallorca for seven years. Jovellanos, who was 54 years old when he came to power and was painted by Goya, is described by a contemporary (Candido Nocedal): 'a well-pro-portioned figure, graceful body, expressive bearing, lively bright eyes, abundant frizzed hair, elegant and easy manners.' Jovellanos is known to have taken much trouble with his hair, here seen carefully dressed, as he refused to wear a wig. Goya has placed his sitter in a rich setting, with muted lighting, seated in melancholy pose, beside an ornate table covered with papers and with an inkwell. A statue of Minerva in bronze is a tribute to the sitter's great learning and distinguished position at the time of the painting. Jovellanos bequeathed Goya's portrait to his friend and protector, Arias de Saavedra.

Jovellanos as well as Goya used the language of satire to attack social and political abuse. The second of Goya's *Caprichos* in which a blind-folded young woman is led to the altar by an ugly old man, takes its caption from a verse by his patron: 'They say yes and offer their hand to the first comer.' The Minister's concern for prison reform also found a response in the artist in his many illustrations of the torture of prisoners.

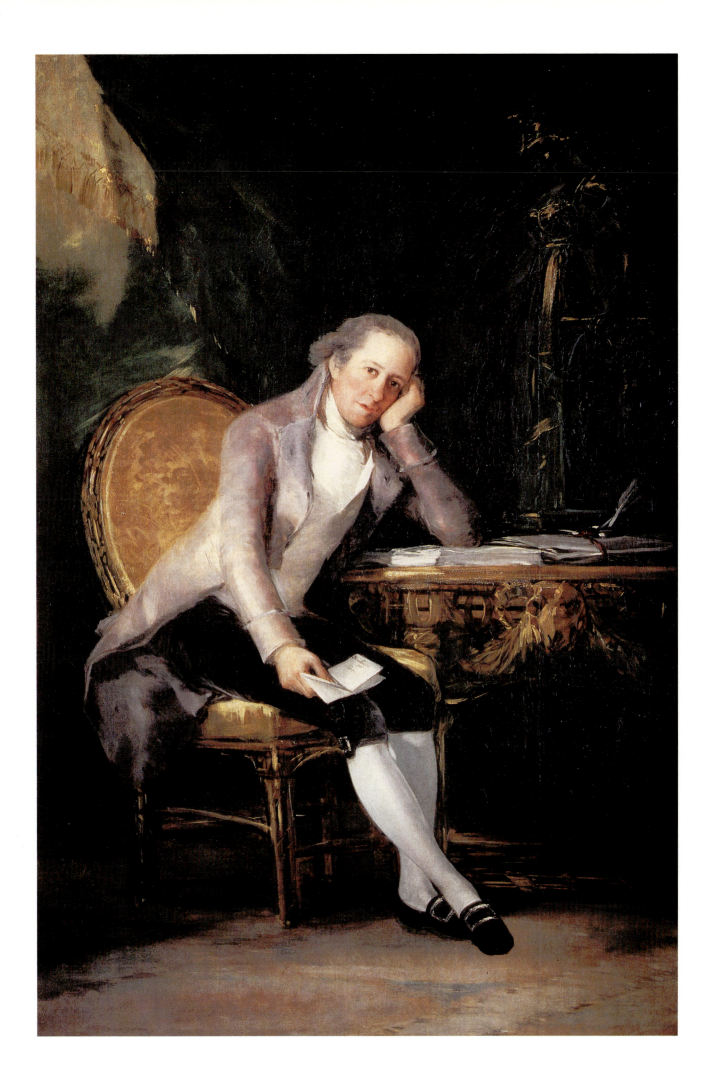

Charles IV and his Family

c.1800. Canvas, 280 x 336 cm. Museo del Prado, Madrid

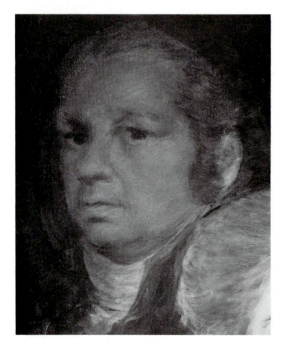

Goya clearly had in mind for this royal group the composition of Velázquez's *Meninas*, which he had copied in an engraving many years before (Fig. 22). Like Velázquez, he has placed himself at an easel in the background, to one side of the canvas (Fig. 23). But his is a more formal royal portrait than Velázquez's: the figures are grouped – almost crowded – together in front of the wall and there is no attempt to create an illusion of space. The eyes of Goya are directed towards the spectator as if he were looking at the whole scene in a mirror. The somewhat awkward arrangement of the figures suggests, however, that he composed the group in his studio from sketches made from life. Goya is known to have made four journeys to Aranjuez in 1800 to paint ten portraits of the royal family. Since there are 12 figures in the group it is likely that the woman seen in profile and the woman whose head is turned away – the only two whose identity is uncertain – were not present at the time.

Goya's magnificent royal assembly is dominated not by Charles IV but by the central figure of the Queen, María Luisa, whose ugly features are accentuated by her ornate costume and rich jewels. For some unknown reason this was the last occasion that Goya is known to have painted any member of this royal family, except for the future Ferdinand VII (Plate 35), who stands in the foreground on the left. The unusual figure composition on the wall behind the group has been identified (by P. Muller, 1984) as *Lot and his Daughters*, but no such painting has been identified.

Fig. 22
Las Meninas, after
Diego Velázquez
c.1778. Etching with
aquatint. British Museum,
London

Fig. 23
Self-portrait, detail
of *Charles IV and
his Family*

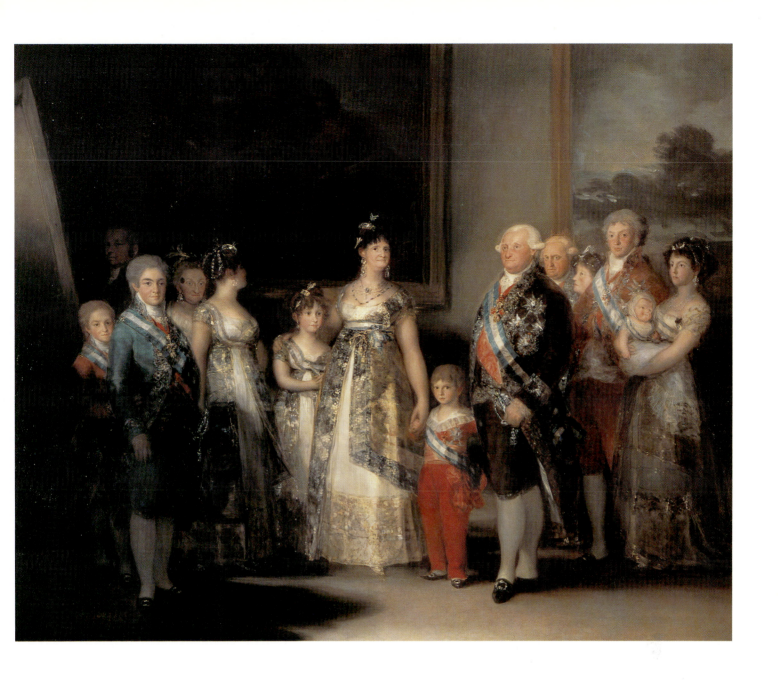

c.1799-1800. Canvas, 97 x 190 cm. Museo del Prado, Madrid

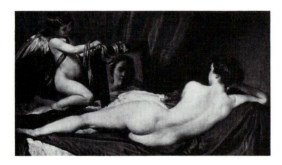

Fig. 24
The Toilet of Venus
('The Rokeby
Venus') (by Diego de
Velázquez)
1649-51. Canvas,
122.7 x 177 cm. National
Gallery, London

Fig. 25
Nude Woman
Holding a Mirror
1796-7. Indian inkwash,
23.4 x 14.5 cm. Biblioteca
Nacional, Madrid

Goya's *Majas* (fashionable young women) are two of his most famous and most discussed masterpieces. Their date, for whom they were painted and the identity of the model are problems that are still not satisfactorily solved. The first mention of *The Nude Maja* is in the diary of the medallist Pedro González de Sepúlveda describing a visit in November 1800 to the house of the Minister, Manuel Godoy, Goya's patron and the target of his satire (see Plate 19): 'In an apartment or inner cabinet are pictures of various Venuses...[among them] a naked one by Goya, without design or delicacy of colouring' and Velázquez's 'famous Venus'. There is no mention of *The Clothed Maja* and presumably it was not there, probably not yet painted.

Godoy's position at court and his known taste for paintings of female nudes (there were many others in his collection) makes it likely that both *Majas* were painted for him. An alternative suggestion is that they were in the Duchess of Alba's collection and acquired by Godoy after her death, together with Velázquez's *The Toilet of Venus* (Fig. 24) and other pictures. Goya's relations with the Duchess of Alba have made her the most popular candidate as a model for the *Majas*, at least as a source of inspiration, supported by the many drawings of herself and members of her household he made during his visit to the Duchess's country estate (see Fig. 17). The lack of resemblance to the heads of Goya's earlier portraits of her is usually explained by the need to conceal her identity. Whoever the model may have been and for whomever the pictures were made, Goya's nude *Maja* is unique and unprecedented in his oeuvre and in Spain, even in Europe, in his time. Velázquez's *Venus*, which Goya must have seen in the Duchess of Alba's collection, is its only comparable predecessor in the life-like portrayal of the female nude. But where the Velázquez is also a mythological painting, Goya's *The Nude Maja* makes no pretence of being anything but the rendering of a naked woman lying on a couch.

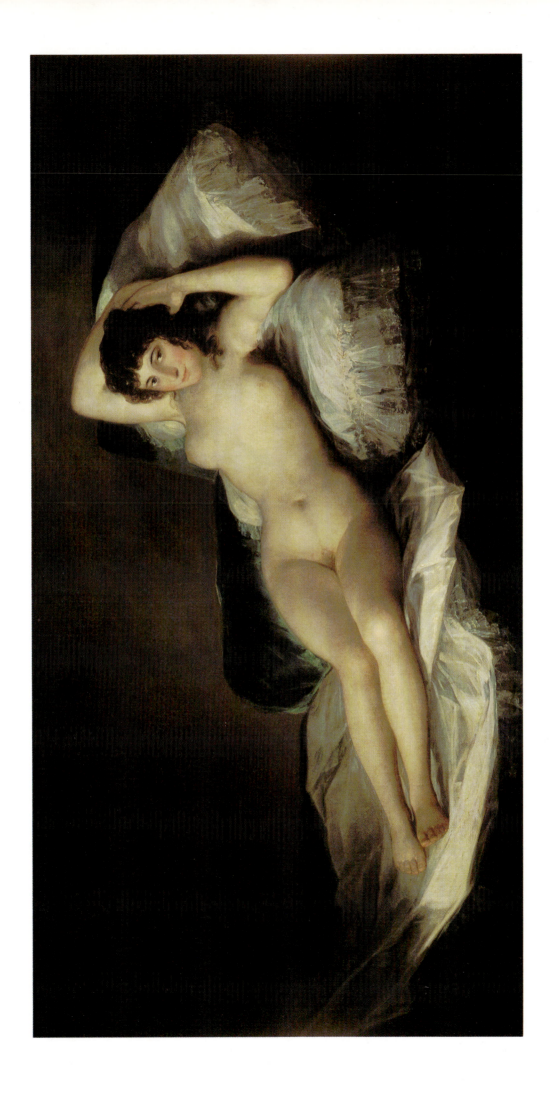

1800-3. Canvas, 97 x 190 cm. Museo del Prado, Madrid

Though it was no doubt painted earlier, the first record of *The Clothed Maja* and the first mention of the paintings together is in an inventory of Godoy's collection dated 1 January 1808, where they are called 'gipsies'. In an article on *Los Caprichos* published in Cadiz in 1811, it is as Goya's *Venuses* that they are mentioned amongst his most admired works (they are also called Venuses in Goya's biography by his son). The next mention of the *Majas* is towards the end of 1814, when Goya was denounced to the Inquisition for being the author of two obscene paintings in the sequestrated collection of the Chief Minister Godoy, 'one representing a naked woman on a bed...and the other a woman dressed as a *maja* on a bed'. On 16 May 1815, the artist was summoned to appear before a Tribunal 'to identify them and to declare if they are his works, for what reason he painted them, by whom they were commissioned and what were his intentions'. Unfortunately Goya's declaration has not yet come to light.

As a pair of paintings of a single figure in an identical pose, the *Majas* are a highly original invention. The theory that the clothed woman was intended as a cover for the naked one is very credible. It is not surprising that the *Majas* attracted the attention of the Inquisition in Madrid in 1814. As late as 1865 Manet's *Olympia* (which bears such a close resemblance to *The Naked Maja* that it is difficult to believe that the artist had not seen Goya's painting) created a furious scandal when it was exhibited in the Paris Salon.

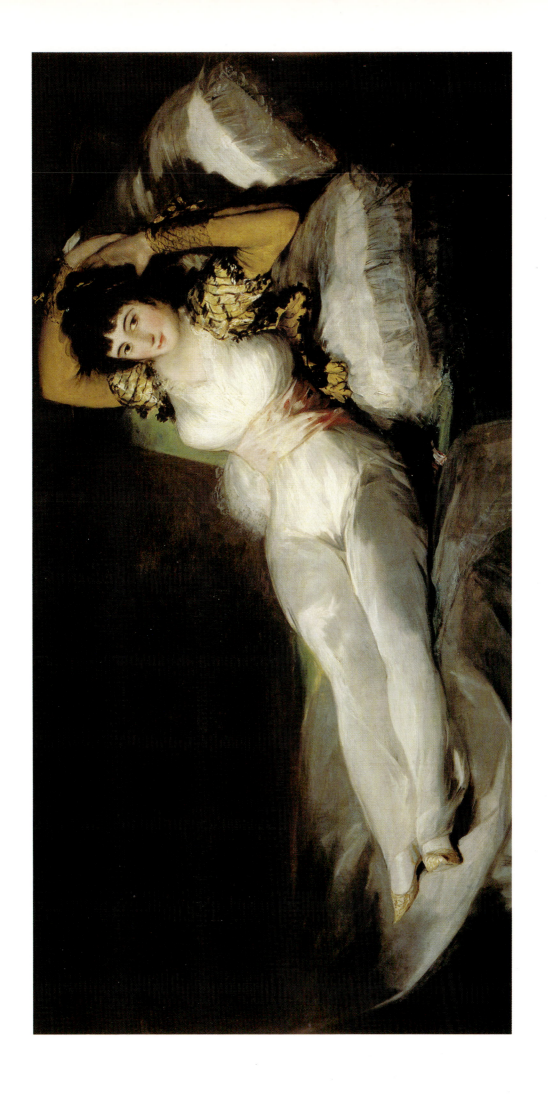

Manuel Godoy, Duke of Alcudia, 'Prince of the Peace'

1801. Canvas, 180 x 267 cm. Royal Academy of San Fernando, Madrid

Fig. 26
Birds of a Feather
(*Tal para qual*)
1799. From the series *Los Caprichos*, Plate 5. Etching and aquatint, 20 x 15.1 cm

This portrait was painted between July and October 1801 to commemorate the victory in Portugal, the War of the Oranges, so-called because Godoy, Chief Minister, is said to have sent a gift of oranges to the Queen in celebration. The Portuguese banners prominent in the foreground were awarded to Godoy in July and in October he was made Generalissimo of land and sea, which entitled him to wear a blue sash in place of the red sash of Captain General, which he wears here. Goya has portrayed Godoy in an elaborate and unusual composition, in a reclining posture reminiscent of some of his paintings of women on couches, seemingly inappropriate for the hero of a military victory. Goya's portrait hints at disrespect for the pomposity of his sitter, though Godoy was an important patron, a collector on a grand scale, for whom Goya painted many works including the famous portrait of his wife, the Countess of Chinchón. Godoy was also owner of the two *Majas* (Plates 17, 18) and may even have commissioned them. Goya's friendship with liberal ministers, such as Jovellanos (Plate 15) and Saavedra (Fig. 21), did not affect the relationship between the First Court Painter and the Chief Minister, whose rapid rise to power, attributed to his liaison with the Queen, made him notorious. Godoy must have been aware of the fact that he had been and still was the target of Goya's satirical wit in several plates of *Los Caprichos*, the ass looking up his genealogy in a book illustrated with row after row of asses, for instance, and in Fig. 26 entitled *Birds of a Feather* (*Tal para qual*) . According to contemporary commentaries this is a reference to Godoy and Queen María Luisa, in particular to an occasion when she was mocked by a group of washerwomen for her unseemly behaviour. Yet despite all this, Godoy in his *Memoirs* written years later in France referred to Goya's *Caprichos* with pride as if he had been responsible for their publication.

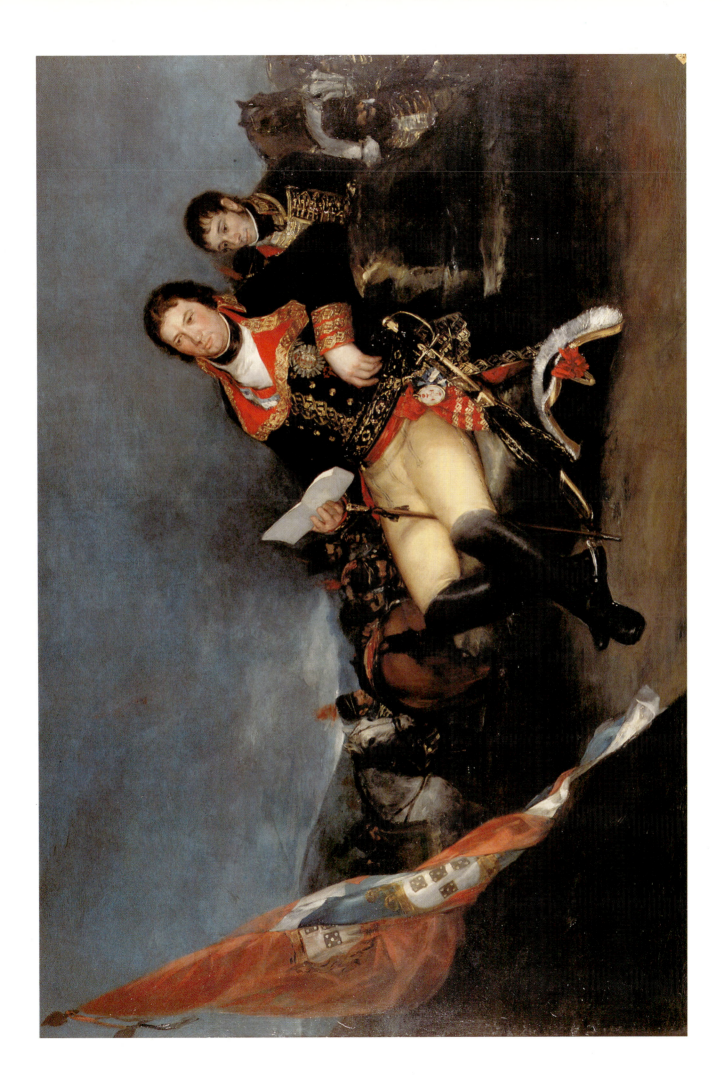

Portrait of Antonia Zárate

c.1805. Canvas, 103.5 x 81.9 cm. National Gallery of Ireland, Dublin

The sitter was a leading actress, mother of the playwright Gil y Zárate and one of several members of the theatrical world portrayed by Goya. She was born in 1775 and was 30 years old at the time when this portrait was probably painted. She died in 1811. Another bust portrait (Fig. 27) has been dated earlier by some critics and later by others. But the pose and details of her face and coiffure are so similar – only the dress and fancy headdress are different – that the two portraits cannot be very different in date. The liveliness of the close-up view of the bust portrait suggests that this may be Goya's first likeness of his beautiful sitter, later transformed into a grand composition. The problem of dating two versions of the same subject is not uncommon in Goya's oeuvre. The yellow settee appears in other portraits by Goya (for example the portrait of Pérez Estala in the Kunsthalle, Hamburg) and was probably a studio property. Nowhere, however, does it provide a more effective setting than here, as a background to the lovely dark-haired actress.

Fig. 27
Antonia Zárate
c.1805. Canvas, 71 x 58
cm. Formerly Howard B.
George Collection,
Washington, DC

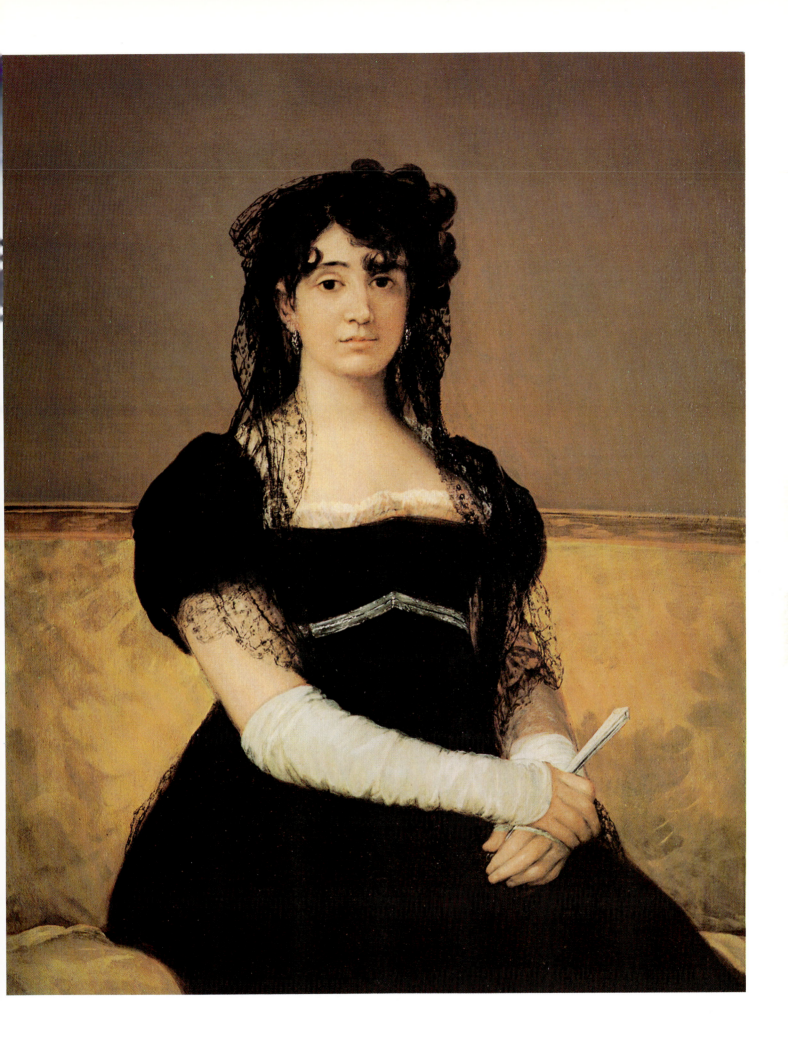

Portrait of a Lady with a Fan

c.1806-7. Canvas, 103 x 83 cm. Musée du Louvre, Paris

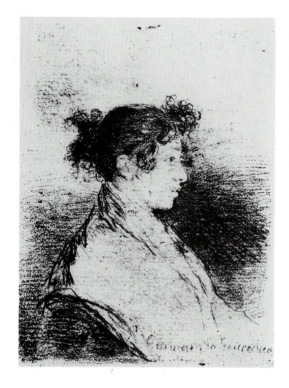

Fig. 28
Gumersinda
Goicoechea, Goya's
daughter-in-law
1805. Black chalk,
11 x 8.2 cm. Carderera
Collection, Madrid

It has been suggested that this handsome, plump young woman is Goya's daughter-in-law, Gumersinda Goicoechea, and that the portrait was painted shortly before or shortly after the birth of his grandson Mariano (see Plate 23). Though it is difficult to judge the resemblance to Goya's other portraits of Gumersinda – a profile drawing (Fig. 28), a miniature in near profile and a full-length portrait of a much slimmer and more elegant figure, with a different coiffure – there is a similarity in the features that makes the identification credible. The portrait was in the collection of Goya's son but when it left his collection the name of the sitter was forgotten.

1810. Canvas, 104.5 x 83.5 cm. The National Gallery of Art, Washington, DC

The sitter, only six or seven years old, wears the uniform of page to Joseph Bonaparte. He was the nephew of General Nicolas Guye, who was also portrayed by Goya in 1810 (Virginia Museum of Fine Arts, Richmond). According to an inscription on the back of the canvas, the two portraits were painted as pendants. During the French occupation of Madrid – at the time when he was working on the drawings for the *Desastres de la Guerra* – Goya painted several portraits of Frenchmen and pro-French Spaniards. Little or nothing of his avowed hostility to the French invaders is revealed in these works, least of all in this sympathetic portrayal of a French child.

Portrait of Mariano Goya, the Artist's Grandson

23

c.1812-14. Panel, 59 x 47 cm. Duke of Albuquerque, Madrid
Signed on the back of the panel '*Goya, a su nieto*' ('Goya, to his grandson')

Goya's only grandson, Mariano, was born on 11 July 1806. There is an earlier full-length portrait of him by Goya aged about four and a head and shoulders of him as a young man in 1827. In the present portrait he appears to be six to eight years old. Seated beside an enormous musical score he is beating time with a roll of paper. This natural gesture, the informal pose and the thoughtful look on the child's face combine to make this one of the most intimate of Goya's portraits and reflects the great affection that he is known to have had for his grandson.

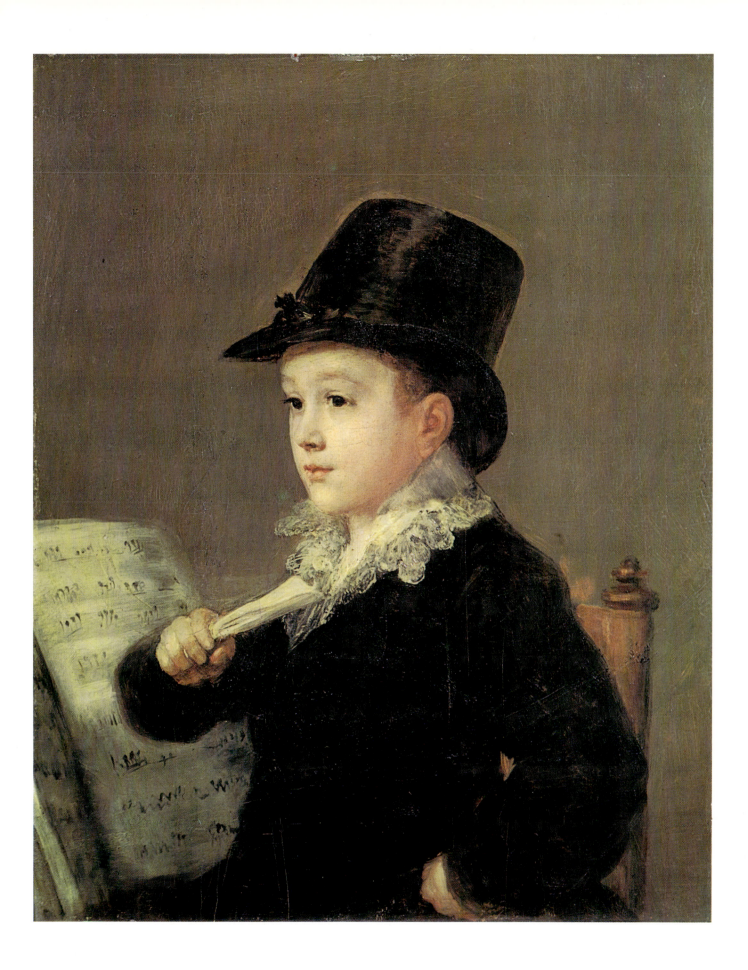

Allegory of the City of Madrid

1810. Canvas, 260 x 195 cm. Museo Municipal, Madrid

At the end of 1809, during the French occupation of Madrid, Goya was chosen as '*el pintor madrileño por excelencia*' to paint a portrait of Joseph Bonaparte for the City Council. In the absence of the French King, Goya composed this picture, described at the time as 'certainly worthy of the purpose for which it was intended', introducing the portrait of Joseph (after an engraving) in the medallion, to which the figure personifying Madrid points. With the changing fortunes of the war this portrait was replaced (by other hands) by the word '*Constitución*', by another portrait of Joseph, again by '*Constitución*' and at the end of the war by a portrait of Ferdinand VII. Eventually in 1843 it received the present inscription '*Dos de Mayo*' ('The second of May') in reference to the popular rising against the French in Madrid in 1808 (see Plate 36). The surprisingly conventional allegorical composition is perhaps dictated by the purpose for which it was originally painted. It contrasts strikingly with the realism and fervour of the scenes from the rising which Goya painted four years later (Plates 36, 37).

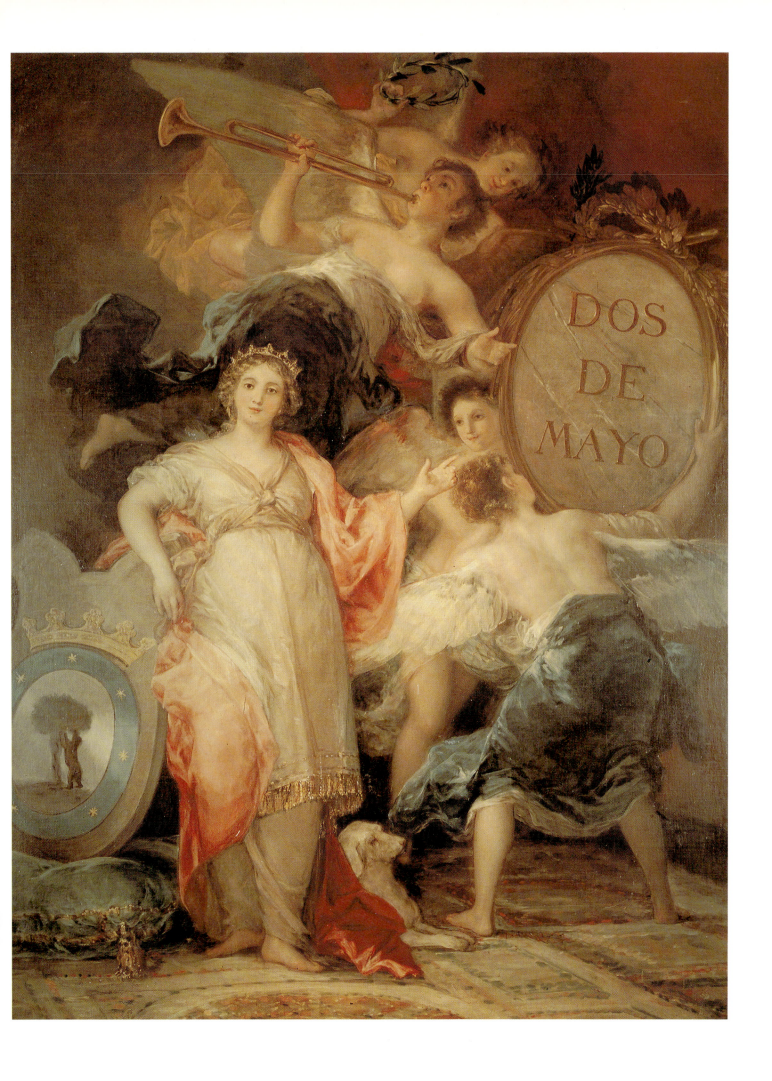

A Woman Reading a Letter

c.1812-14. Canvas, 181 x 122 cm. Musée des Beaux-Arts, Lille

Like many other uncommissioned works, the subject of this painting has been interpreted in various ways and it has borne several descriptive titles. The woman reading the letter has been thought to be a portrait. One critic even suggested that she was the Duchess of Alba (who had died many years before the painting was made), and that she is represented with washerwomen in the background to illustrate a theme of 'Industry and Idleness'. It has also been suggested that Goya intended this painting as a pendant to *Time and the Old Women* (Plate 26). The two canvases are almost exactly the same size, were acquired for the Musée des Beaux-Arts, Lille, at the same time and have the same provenance. But there seems to be no obvious connection between the subjects of the two paintings and *Time and the Old Women*, which is known to have been in Goya's possession in 1812, is almost certainly a slightly earlier work. There is, in fact, little reason to doubt that the woman reading a letter, standing with her companion and a dog in front of a group of washerwomen, is a genre subject like the earlier tapestry cartoons and other decorative paintings. But the composition is less contrived and, as in many other works, chiefly the uncommissioned ones, it appears to be based on a scene that the artist had witnessed and recorded on the spot or from memory. This was one of four paintings by Goya in the collection of King Louis Philippe which had been obtained in Madrid from Goya's son (see also Plate 39). It was sold at Christie's, London, in 1853 for £21.

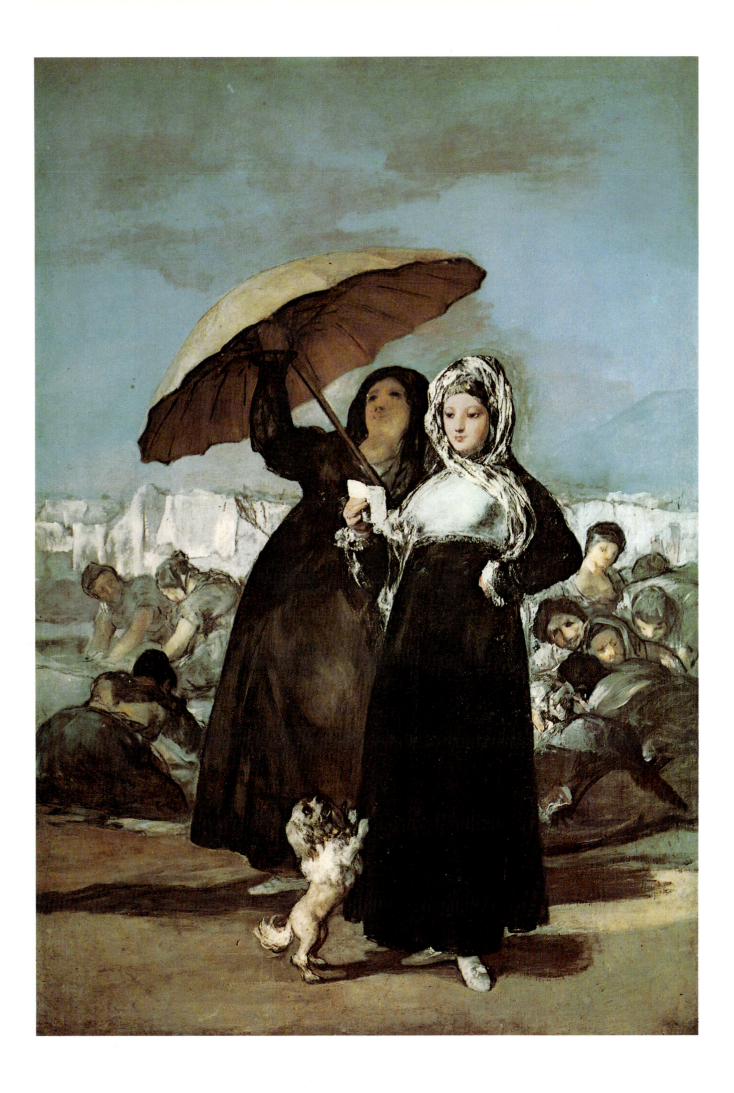

c.1810-12. Canvas, 181 x 125 cm. Musée des Beaux-Arts, Lille

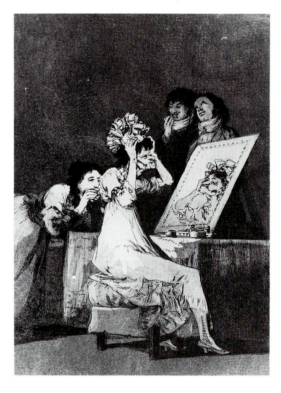

Fig. 29
Until Death
(*Hasta la Muerte*)
1799. From the series
Los Caprichos, Plate 55.
Etching and aquatint,
21.8 x 15.2 cm

The mark 'X23' at the bottom of the canvas identifies this as a painting listed in 1812 in the inventory of paintings in Goya's house allocated to his son Javier. It probably hung next to one or other of two versions of *Majas on a Balcony* that bears the number X24. The painting of *A Woman Reading a Letter* (Plate 25), long thought to have been a pendant and later sharing the same history, was possibly intended as such, although painted a year or two later. Exceptional in its way as a life-size *Capricho*, the scale makes the satirical purport the more forceful. But though the general meaning is clear – the ridiculing of the pretentiousness and vanity of the rich and old and ugly – the exact message '*Que tal?*' ('How goes it?') on the back of the mirror is not spelt out. A similar theme, without the figure of Time, which is the subject of Plate 55 of *Los Caprichos* (Fig. 29), has lent itself to interpretation as a reference to the Dowager Duchess of Osuna, and also to Queen María Luisa, renowned for her vanity and her ugliness. In support of such an allusion, though the Queen had long since left Spain when this painting was made, one of these old women wears a diamond arrow similar to that worn by María Luisa in the group portrait of *Charles IV and his Family* (Plate 16).

Goya's son was no doubt referring to this and other paintings that Goya owned in 1812 when he wrote in one of his biographies of his father that Goya was specially interested in the paintings in his house 'because they were made with all the liberty that ownership affords; a liberty which led him in some cases to use the palette knife instead of the brush...and he particularly enjoyed seeing them every day'.

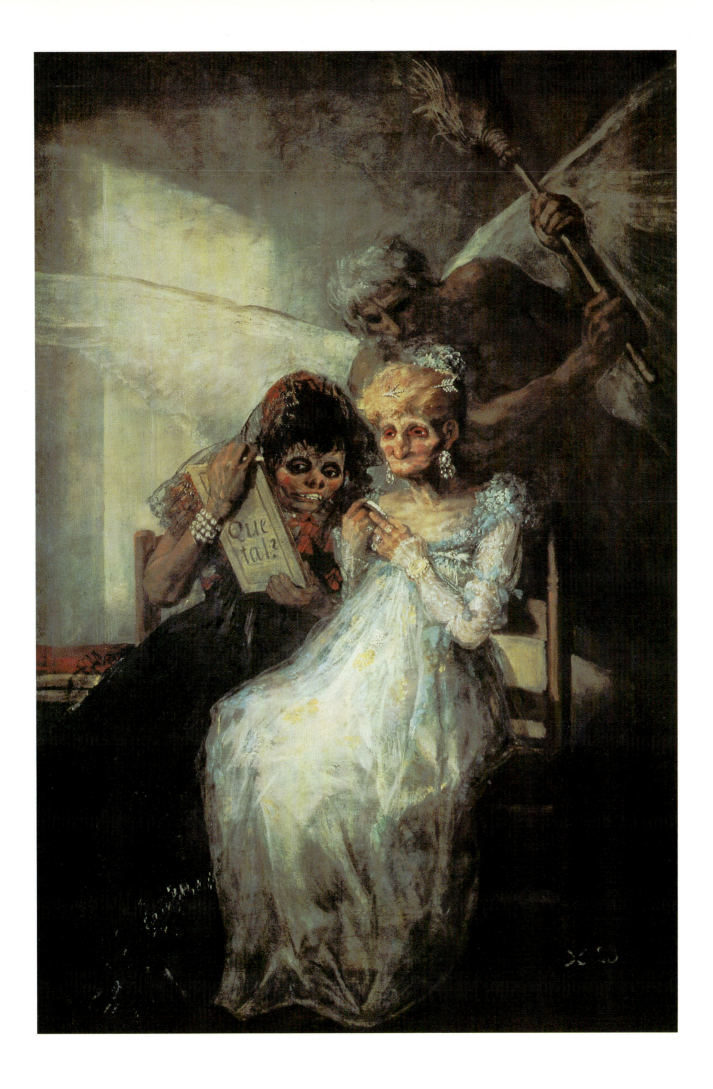

The Burial of the Sardine

c.1812-14. Panel, 82 x 60 cm. Royal Academy of San Fernando, Madrid

Fig. 30
Burial of the Sardine
c.1813-14. Pen and sepia
ink, 22 x 18 cm.
Museo del Prado, Madrid

This painting, together with *A Procession of Flagellants* (Plate 28), *A Village Bullfight* (Plate 29), *The Madhouse* (Plate 30) and a fifth, representing an Inquisition scene, entered the Academy in 1839 as the bequest of Manuel García de la Prada, who had been a patron of the artist. In his will, dated 17 January 1836, they are described as 'Five pictures on panel, four of them horizontal, representing an *auto da fé* of the Inquisition, a procession of flagellants, a madhouse, a bullfight; another which is larger represents a masked festival; all painted in oil by the celebrated Court Painter don Francisco de Goya, and much praised by the Professors.' The history of these five paintings before they entered García de la Prada's collection is not known, now that they are no longer associated with the cabinet pictures made in 1793. They are now dated considerably later and the inclusion of the Inquisition scene suggests that they were probably painted after the suppression of the Inquisition in 1810, especially in view of the trouble Goya himself said he had with the Holy Office over *Los Caprichos*. The masked festival represents the 'Burial of the Sardine', a popular Spanish festival marking the end of Carnival and beginning of Lent, which still takes place in some parts of the country. In a sketch for the painting (a drawing in the Prado), the banner is differently decorated and carries the inscription *Mortu[u]s* (Fig. 30). The festive scene is brought to life in a bold sketchy style. The treescape in the background is similar to that of the tapestry cartoons but there is much more movement among the figures, and the fixed expressions on many of the faces in the cartoons are here recalled by the masks worn by the principal actors.

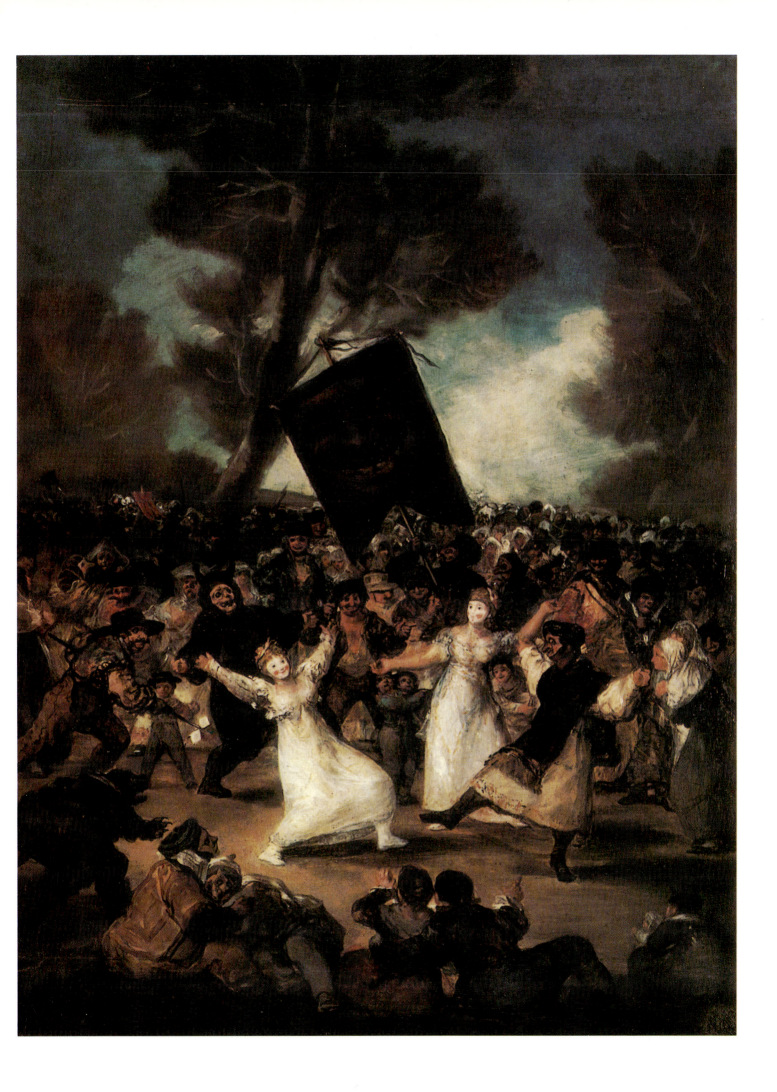

A Procession of Flagellants

c.1812-14. Panel, 46 x 73 cm. Royal Academy of San Fernando, Madrid

This work has the same provenance and dating as Plates 27, 29 and 30. The participation of flagellants in Holy Week processions in Spain was banned in 1777 but evidently not effectively since the ban was published again in 1779 and 1802. Goya's known hatred of fanaticism, explicit in many later drawings and engravings, suggests that his choice of subject was intended as an indictment of this form of public penance. So does his manner of recording the scene. The holy image of the Virgin is silhouetted against the dark wall of the church and the blood-stained figures of the flagellants stand out from and dominate the procession. An Inquisition scene in the same series is similar in character. Both paintings combine realistic reportage with critical intent in a manner, often seeming to approach caricature, which is peculiar to Goya. Many years later he returned to the subject in a drawing entitled *Holy Week in Spain in Times Past* (Fig. 31).

Fig. 31
Holy Week in Spain
in Times Past
(*Semana Santa en
Tiempo Pasado en
España*)
c.1820-4. Black chalk,
19.1 x 14.6 cm. National
Gallery of Canada, Ottawa

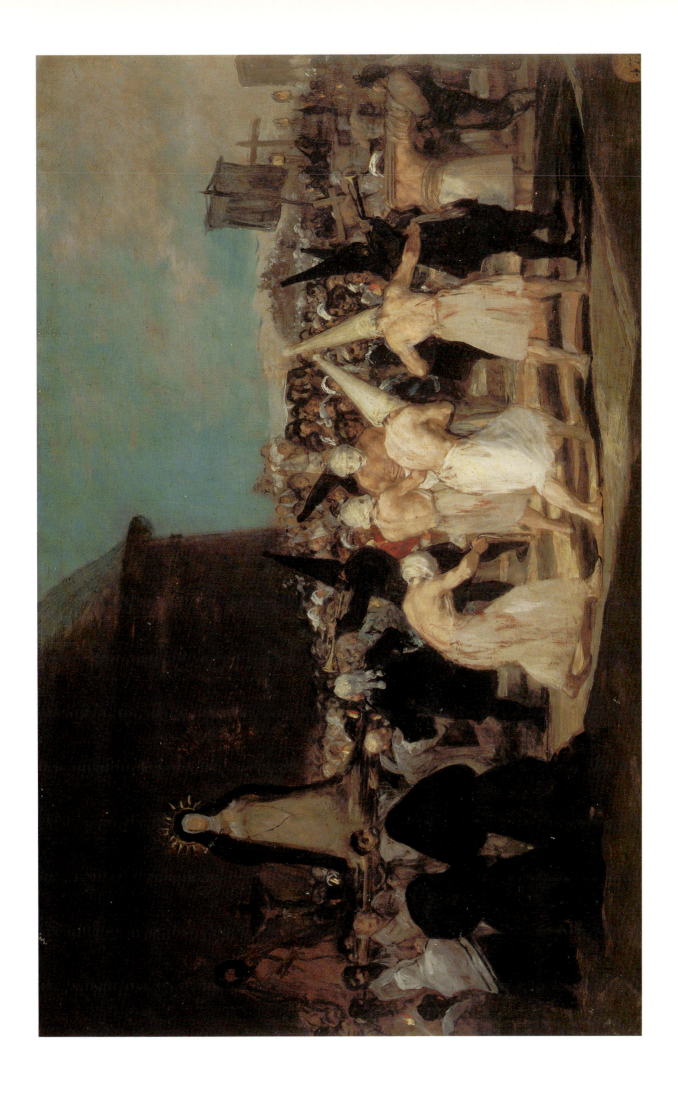

A Village Bullfight

c.1812-14. Panel, 45 x 72 cm. Royal Academy of San Fernando, Madrid

The same history and dating as Plates 27, 28, 30. Although many of his contemporaries were opposed to bullfighting (Charles III imposed restrictions on the sport; it was banned in 1808 but the ban was lifted by Joseph Bonaparte in 1810), there is every reason to believe that Goya was an *aficionado*. There is even some truth in the stories of his performance in the ring. In a letter of 1823, his friend Moratín writes from Bordeaux: 'Goya says that he has fought bulls in his time and that with his sword in his hand he fears no-one.' Goya made portraits of several bullfighters and many paintings, drawings and engravings of the national sport. A scene of the baiting of young bulls (*La Novillada*), in which he portrayed himself, was the subject of one of his early tapestry cartoons, and a rounding up of bulls (*El encierro de los toros*) was one of his decorations for the Osuna country residence. In 1816 he published the *Tauromaquia*, a series of 33 etchings, for which he had made many drawings. Among his last works executed in France is a set of four lithographs, the *Bulls of Bordeaux* (see Fig. 32). *A Village Bullfight* is one of his most impressive paintings of the subject. The sketchy style and dark tones create a vivid impression of the actions of the protagonists and of the dense crowd of spectators grouped round the scene. It was perhaps in a setting such as this that Goya himself sometimes entered the ring as an amateur bullfighter.

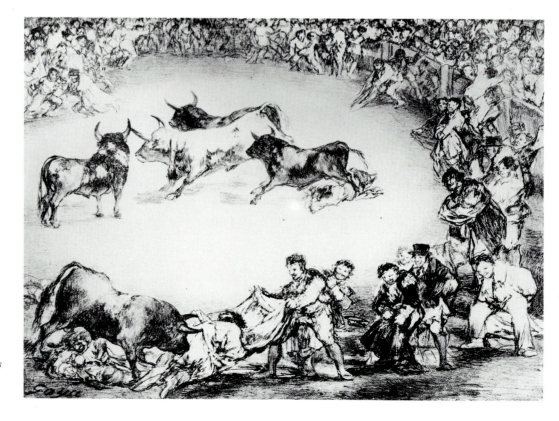

Fig. 32
Spanish
Entertainment
(*Dibersion de España*)
1825. One of the four *Bulls of Bordeaux*. Lithograph,
30 x 41 cm Signed '*Goya*'

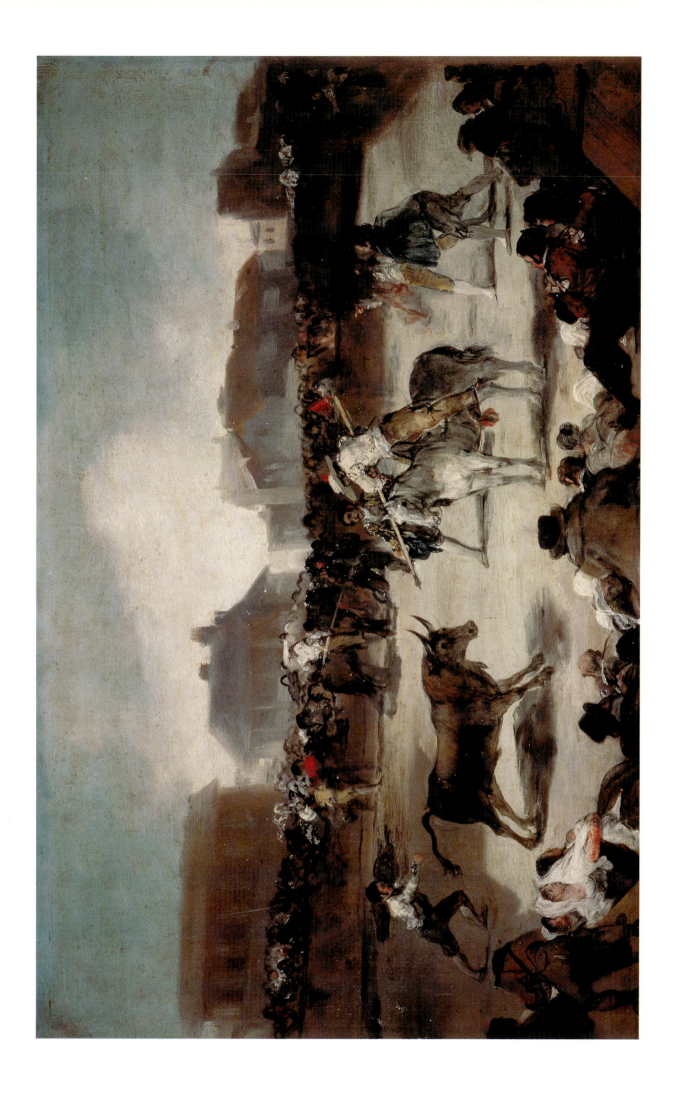

The Madhouse

c.1812-14. Panel, 45 x 72 cm. Royal Academy of San Fernando, Madrid

This work has the same history and dating as Plates 27, 28 and 29. In many ways this version of a lunatic asylum is more conventional than Goya's earlier eye-witness account of *The Yard of a Madhouse* (Plate 8). It has been compared with Hogarth's scene in Bedlam in the *Rake's Progress* and some of Goya's deranged men, like Hogarth's, wear traditional attributes – a crown, a feathered headdress and tarot cards. But Goya's Bedlam is a much more horrifying sight, a place of darkness only partially lit, with the postures, gestures and expressions of the inmates indicating their pitiful condition. This is a dramatic and compassionate expression of the kind of scene he saw in Saragossa. Goya's life-long concern for the plight of the insane as well as of prisoners and his continued interest in the physiognomy of madness is evident from the many drawings he made of various conditions of insanity (see Fig. 16).

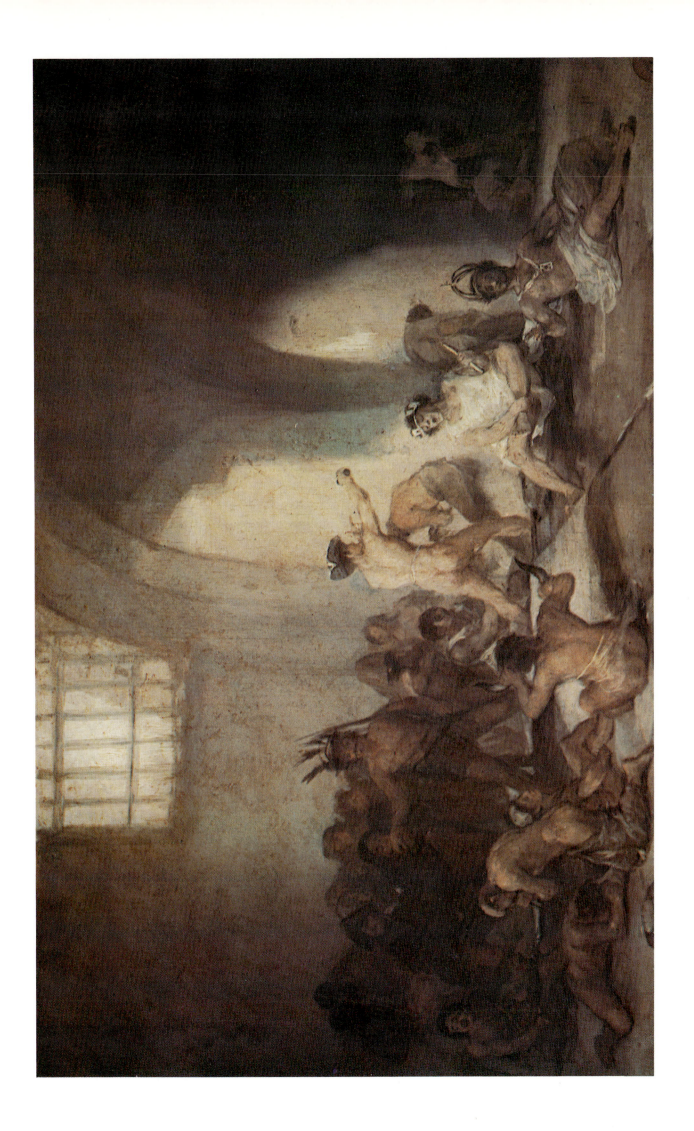

A Prison Scene

c.1810-14. Zinc, 42.9 x 31.7 cm. Bowes Museum, Barnard Castle

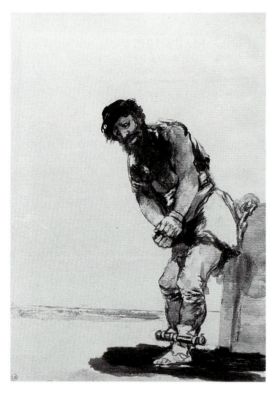

Fig. 33
Chained Prisoner
c.1806-12. Indian ink
wash, 21.8 x 15.1 cm.
Musée Bonnat, Bayonne

Fig. 34
The Captivity is as
Barbarous as the
Crime (*Tan Barbara la
Seguridad como el
Delito*)
c.1810-20. Etching and
burin, 11 x 8.5 cm

This prison scene is related in style and character to a number of small paintings of war scenes and other subjects inspired by the Napoleonic invasion. Prisoners – not only prisoners of war – are among the victims of injustice and cruelty that figure in many of Goya's drawings (Fig. 33) and engravings. A garroted man is the subject of one of his earliest etchings and various other forms of punishment and torture are represented in later graphic works. Three etchings of about 1815 show chained and shackled prisoners very similar to those in the painting (Fig. 34). This prison scene, executed with a minimum of colour, is remarkable for the atmosphere of gloom and the effect of anonymous suffering created by the lightly painted, indistinct figures in an enormous cavern-like setting.

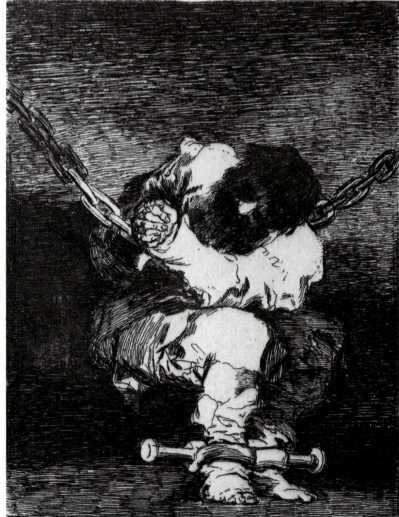

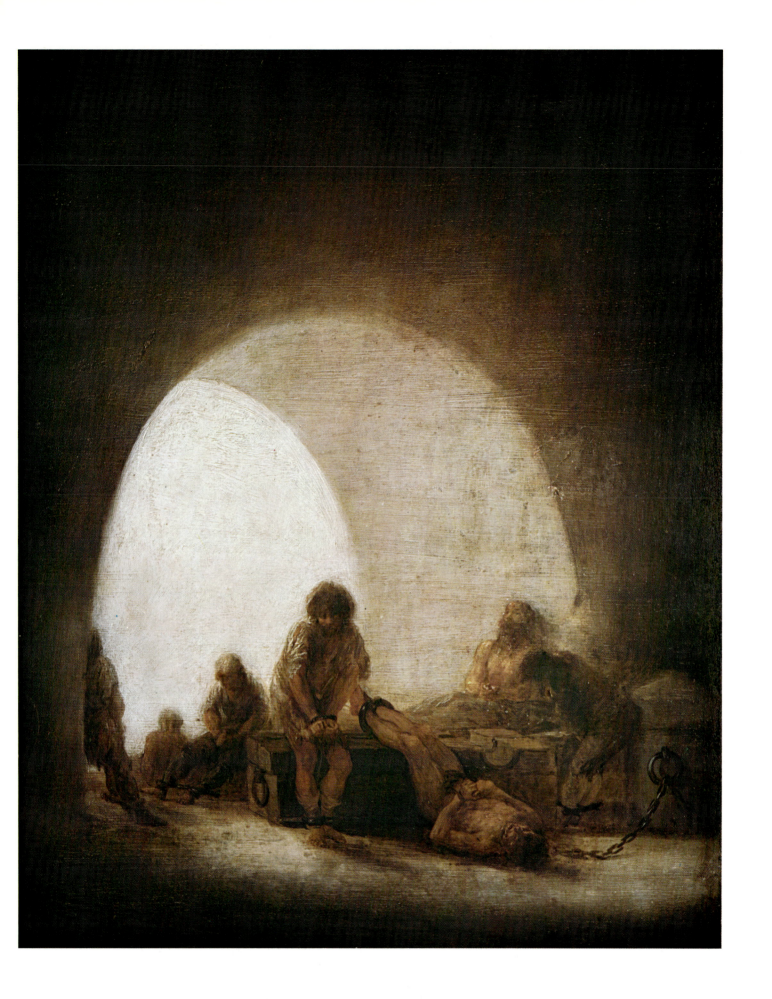

c.1810-12. Canvas, 116 x 105 cm. Museo del Prado, Madrid

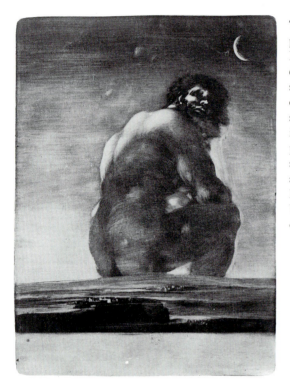

Fig. 35
The Colossus
c.1810-18. Goya's only
mezzotint engraving,
28.5 x 21 cm

This moving and enigmatic painting, listed in the inventory of Goya's possessions in 1812, certainly relates to the Napoleonic invasion of Spain. In 1812 it was called *El Gigante* ('*The Giant*'). Today it is known as *The Colossus* or *Panic*, titles which are more expressive, though its meaning is still problematic. The giant torso, rising out of the clouds behind a scene of men and animals put to flight, has been interpreted alternatively as a symbol of Napoleon and of War. It has been suggested that Goya's painting may have been inspired by J. B. Arriaza's *Profecía del Pirineo*, a patriotic poem that had been in circulation since 1808, in which a Colossus, as the spirit or guardian of Spain, rises against Napoleon and the French forces and defeats them. A later engraving by Goya, also formerly described (by his grandson) as a 'giant' (Fig. 35), shows a similar figure seated on a hill beneath a crescent moon, a meditative, passive counterpart to the threatening Colossus of the painting.

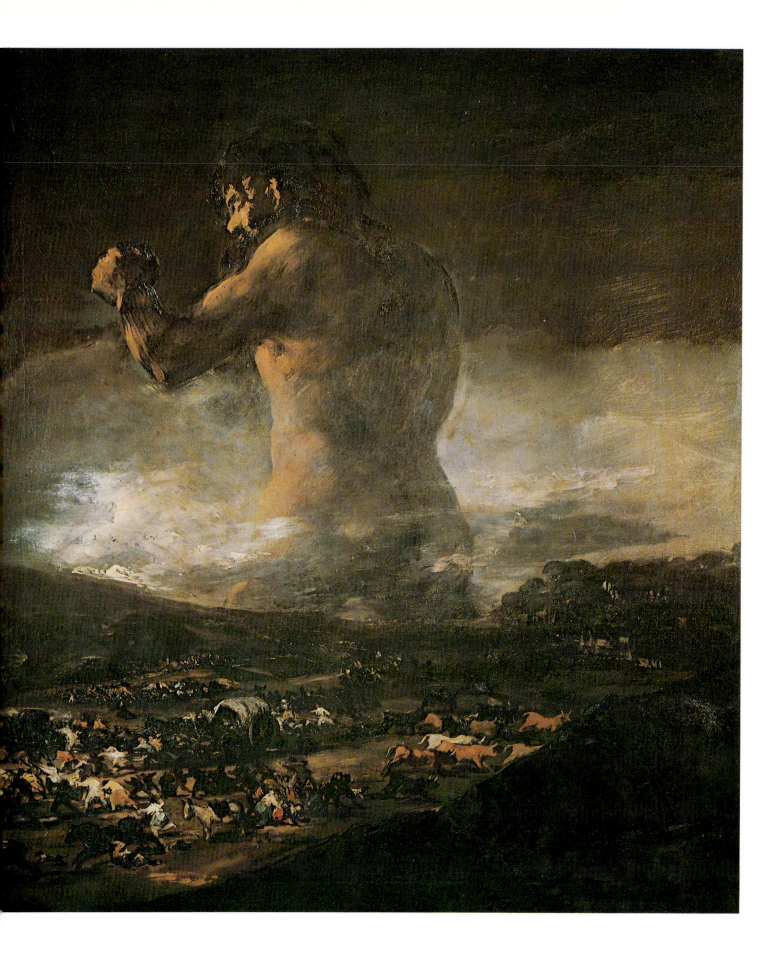

Still Life: A Butcher's Counter

c.1810-12. Canvas, 45 x 62 cm. Musée du Louvre, Paris
Signed '*Goya*'

A dozen *bodegones* (still lifes) and a painting of birds are recorded in the inventory of Goya's possessions made in 1812 after the death of his wife, and according to his French biographer, Matheron, he painted several still lifes in the market at Bordeaux during his last years there. The present example bears traces of the inventory mark that identifies the earlier group, and is remarkable for the period because of the casual arrangement of the sheep's head with its expressive eye, and sides of mutton. The signature is painted in red as if to simulate blood. For stylistic reasons this and other still lifes of the group – pictures of meat, fish, fowl and game – cannot be much earlier than the date they are recorded in Goya's house. This means that they must have been painted about the time of the *año del hambre*, the year of the terrible famine in Madrid in 1811-12, when thousands died of hunger, thus raising the question of whether any allusion to the famine was intended by Goya. Were they perhaps meant as a sardonic commentary on the situation in one of the many illustrations of the effects of famine in his *Desastres de la Guerra*? A well-dressed woman stands before a group of starving victims, some dying, some dead, with the caption: 'The worst is to beg' (Fig. 36).

Fig. 36
The Worst is to Beg
(*Lo Peor es Pedir*)
c.1812-15. From the series
Los Desastres de la Guerra,
Plate 55. Etching and
lavis, 15.5 x 20.5 cm

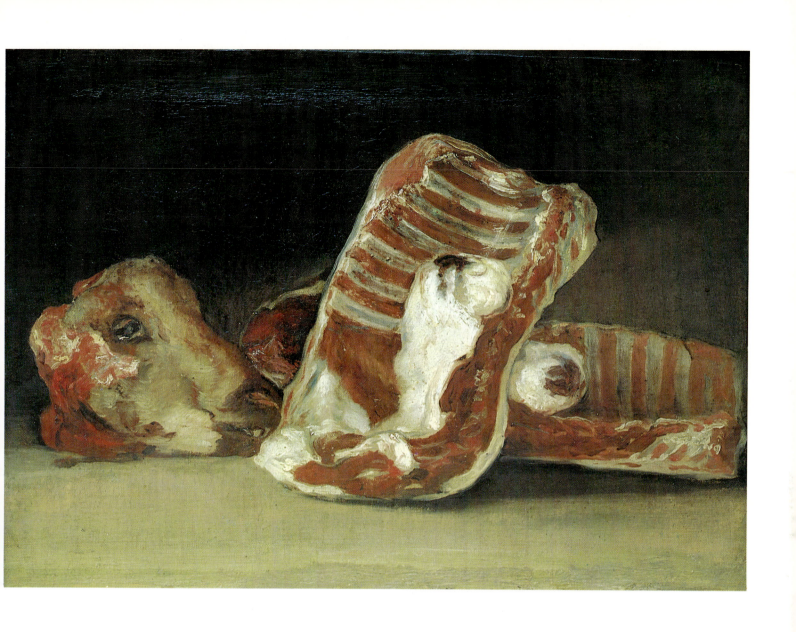

Portrait of the Duke of Wellington

1812. Panel, 64 x 52 cm. National Gallery, London

Fig. 37
The Duke of
Wellington
Red chalk over pencil,
23.2 x 17.5 cm. British
Museum, London
Inscribed (by Carderera)
'*Lord Welingn estudio para*
el retrato equestre qe pinto
Goya' (Lord Wellington,
a study for the portrait
painted by Goya)

There are two known portraits in oils of Wellington by Goya, one large equestrian portrait (Apsley House, London) and this bust as well as two drawings. A third painting of Wellington with hat and cloak (National Gallery of Art, Washington, DC) is no longer considered to be by Goya. All are related, but the order of their execution and their precise interrelations are difficult to determine. It has been suggested that the drawings may have been made in preparation for an etching that was never executed. The British Museum drawing (Fig. 37), in which the head most closely resembles the head in the paintings, may, however, have served as a study for these. An inscription on this drawing says that it was a study for the equestrian portrait and an accompanying note (said to be in the hand either of Goya's grandson or of his friend Carderera), that it was made at Alba de Tormes after the Battle of Arápiles (i.e. Salamanca). The battle was fought on 22 July 1812 and Wellington was at Alba de Tormes on the following day, but it is unlikely that he was able to sit to Goya before he entered Madrid on 12 August. The equestrian portrait, the only one for which documents exist, must have been painted between 12 August and 2 September, when it was to be exhibited in the Academy of San Fernando (*Diario de Madrid*, 1 September). It is of this portrait that Goya writes in a letter: 'Yesterday His Excellency Señor Willington [sic] was here...We discussed showing his portrait to the public in the Royal Academy at which he expressed great pleasure...It is a compliment to His Excellency and to the public.' The letter seems to refute the story of Wellington's disapproval and Goya's violent reaction to it.

The National Gallery painting was probably painted before he left Madrid on 1 September 1812, at the same time as the equestrian composition, when Wellington was still Earl of Wellington and Lieutenant-General. Of the two paintings, the head in the National Gallery version is the most animated and the most likely to have been taken from life. It is also the only one that represents Wellington in full military costume and the most ceremonial in appearance. Some of the decorations that he wears were received after he left Madrid in 1812 and the alterations that are visible in the painting may have been made in May 1814, when Wellington returned there as Ambassador to Ferdinand VII. The portrait is said to have been presented by the Duke to his sister-in-law, the Marchioness of Wellesley.

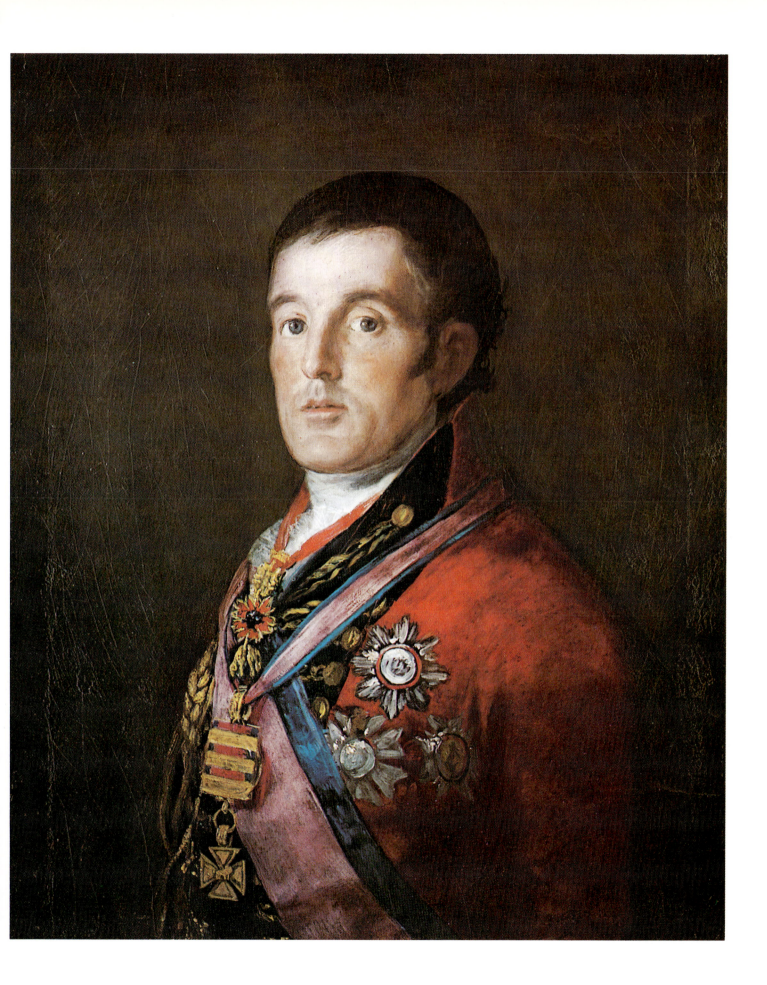

Portrait of Ferdinand VII

c.1814. Canvas, 207 x 144 cm. Museo del Prado, Madrid
Signed (upside down) '*Goya*'

After the restoration of Ferdinand VII in 1814, Goya was commissioned to paint several portraits of him for ministries and public buildings. For these he seems to have used the same study of the King's head, possibly the drawing in the Biblioteca Nacional, Madrid. The pose, the setting and the costume are varied to suit the occasion. The effect – perhaps intentional – is that of a living head on the body of a dummy. In this ceremonial portrait, the King appears in the uniform of a Captain General with a military camp in the background – a conventional formula, since he had taken part in no military campaign, having spent the war years in France. The broad painting of the costume and decorations and the sketchy treatment of the background direct attention to the head of the King which stands out as a grimly realistic character study.

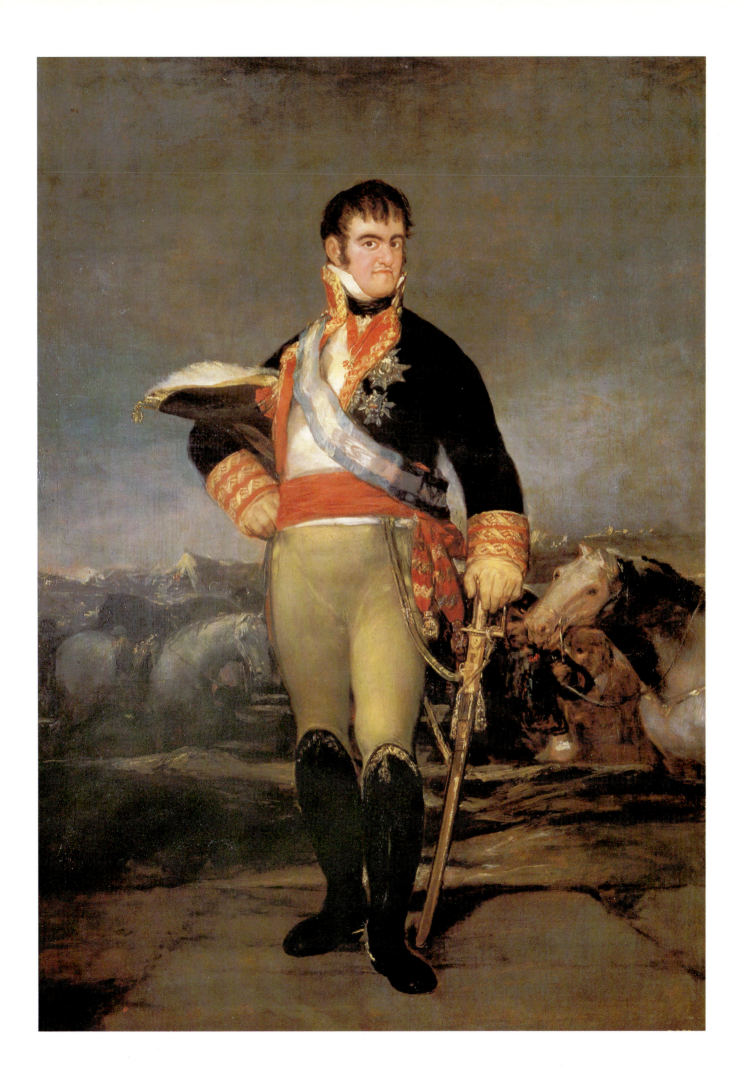

36 The Second of May, 1808:
 The Charge of the Mamelukes

1814. Canvas, 266 x 345 cm. Museo del Prado, Madrid

After the expulsion of the Napoleonic armies in 1814 Goya applied for, and was granted, official financial aid in order 'to perpetuate with the brush the most notable and heroic actions or scenes of our glorious insurrection against the tyrant of Europe'. The two scenes that he recorded (see also Plate 37) are not victorious battles but acts of anonymous heroism in the face of defeat. Here the people of Madrid armed with knives and rough weapons are seen attacking a group of mounted Egyptian soldiers (Mamelukes) and a cuirassier of the Imperial army. The composition, without a focal point or emphasis on any single action, creates a vivid impression of actuality, as if Goya had not only witnessed the scene (as he is alleged to have done) but had recorded it on the spot.

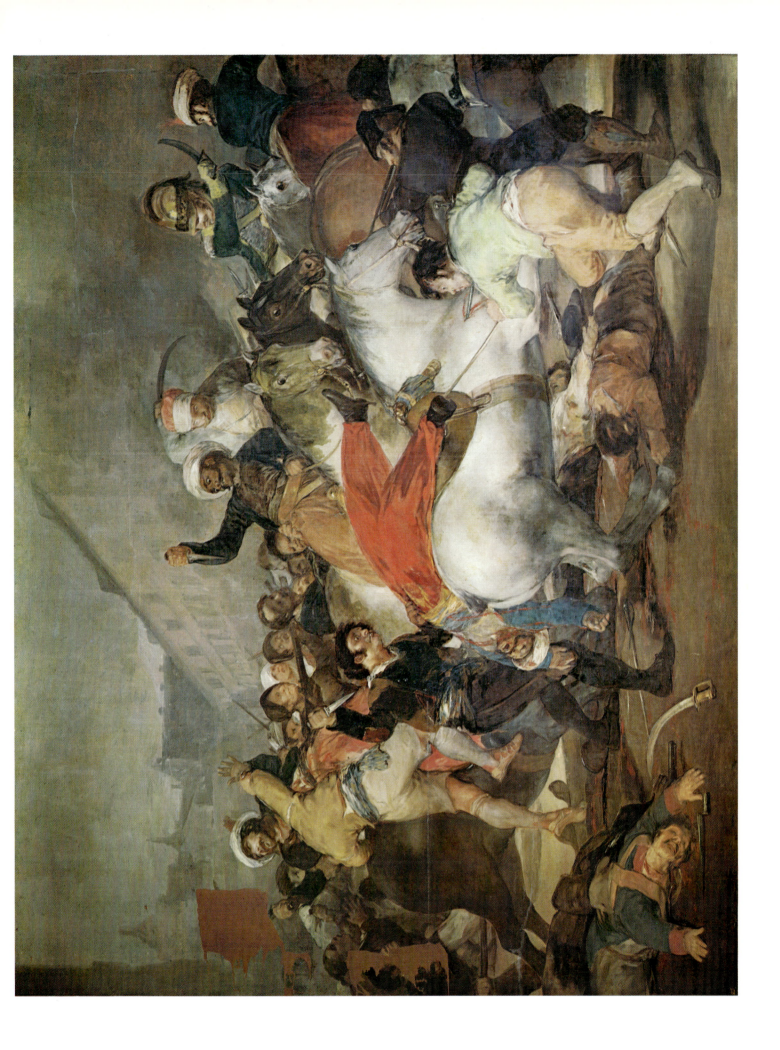

The Third of May, 1808: The Execution of the Defenders of Madrid

1814. Canvas, 266 x 345 cm. Museo del Prado, Madrid

Painted at the same time as *The Second of May* (Plate 36), Goya here represents another of the 'most notable and heroic actions...of our glorious insurrection against the tyrant of Europe' by a dramatic execution scene. The insurrection of the people of Madrid against the Napoleonic army was savagely punished by arrests and executions continuing throughout the night of 2 May and the following morning. There is a legend that Goya witnessed the executions on the hill of Príncipe Pío, on the outskirts of Madrid, from the window of his house and that, enraged by what he had seen, he went to visit the spot immediately afterwards and made sketches of the corpses by the light of a lantern. Whether Goya saw for himself or knew them by hearsay only, the military executions of civilians is a theme that evidently impressed him deeply. He represented it in several etchings of *Los Desastres de la Guerra* and in some small paintings as well as in this monumental picture. Here the drama is enacted against a barren hill beneath a night sky. The light of an enormous lantern on the ground between the victims and their executioners picks out the white shirt of the terrified kneeling figure with outstretched arms. The postures, gestures and expressions of the *madrileños* and the closed impersonal line of the backs of the soldiers facing them with levelled muskets, emphasize the horror of the scene. The dramatic qualities of this composition, with its pity for the execution of the anonymous victims and its celebration of their heroism, inspired Manet's several versions of the *Execution of Maximilian* (Fig. 38).

Fig. 38
The Execution
of Maximilian
by Edouard Manet
1868. Lithograph,
33.3 x 43.3 cm

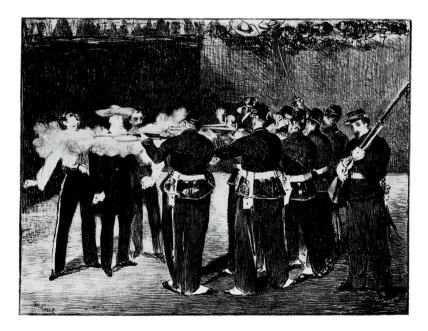

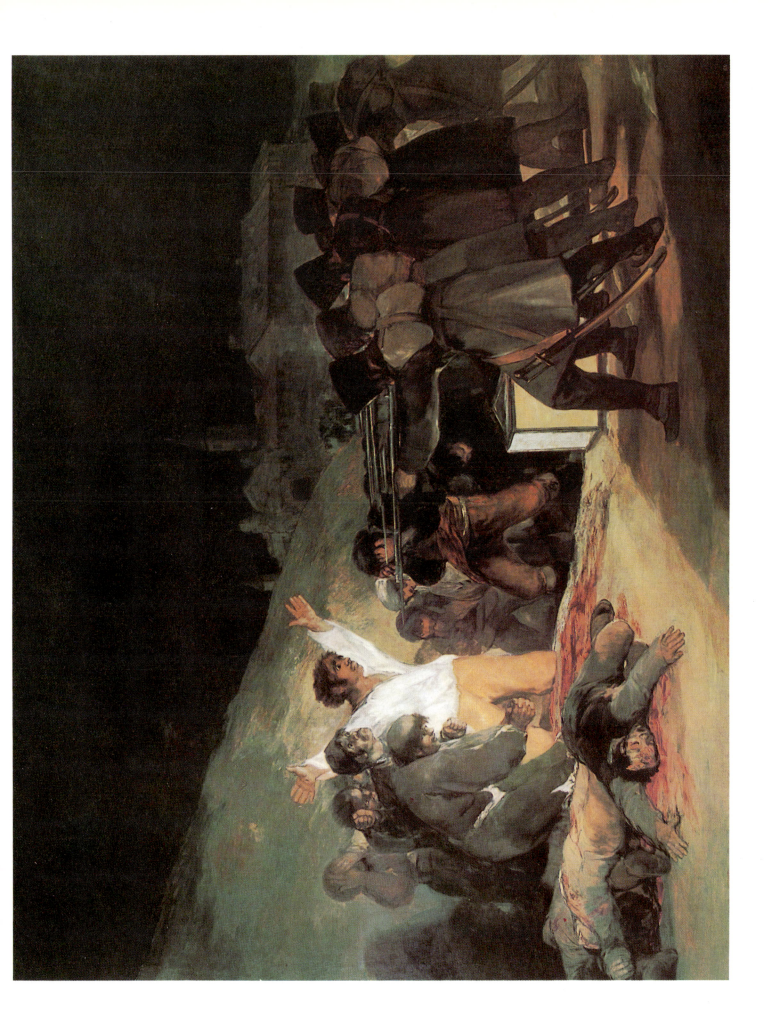

38 Self-portrait

1815. Panel, 51 x 46 cm. Royal Academy of San Fernando, Madrid
Signed '*F. Goya, 1815*'

The tilt of the head and concentrated expression of the eyes suggest that the artist has portrayed himself looking in a mirror or at the easel on which he is painting. Of the numerous self-portraits that Goya made during the course of his life, this painting, made when he was 69 years old, is perhaps the most intimate, with the exception of the likeness on his sick bed, frail and suffering, made five years later. A *Self-portrait* in the Prado, signed and bearing the same date (discovered during recent cleaning), is similar in style and general appearance but there are slight variations in the pose and costume and in the expression of the face, which seems to reflect a more melancholy mood.

The portrait remained in Goya's possession until his death, when it passed to his son. He presented it to the Academy in 1829 when the debt for the equestrian portrait of Ferdinand VII, commissioned by the Academy and painted by Goya in 1808, was finally liquidated. Because of the unusual position of the head it was once suggested that this was a sketch for the *Self-portrait with Dr Arrieta* (Plate 43) but the direction of the head is different and this is the face of a 69-year-old, looking weary perhaps but with no sign of the ravages of illness that were to transform it.

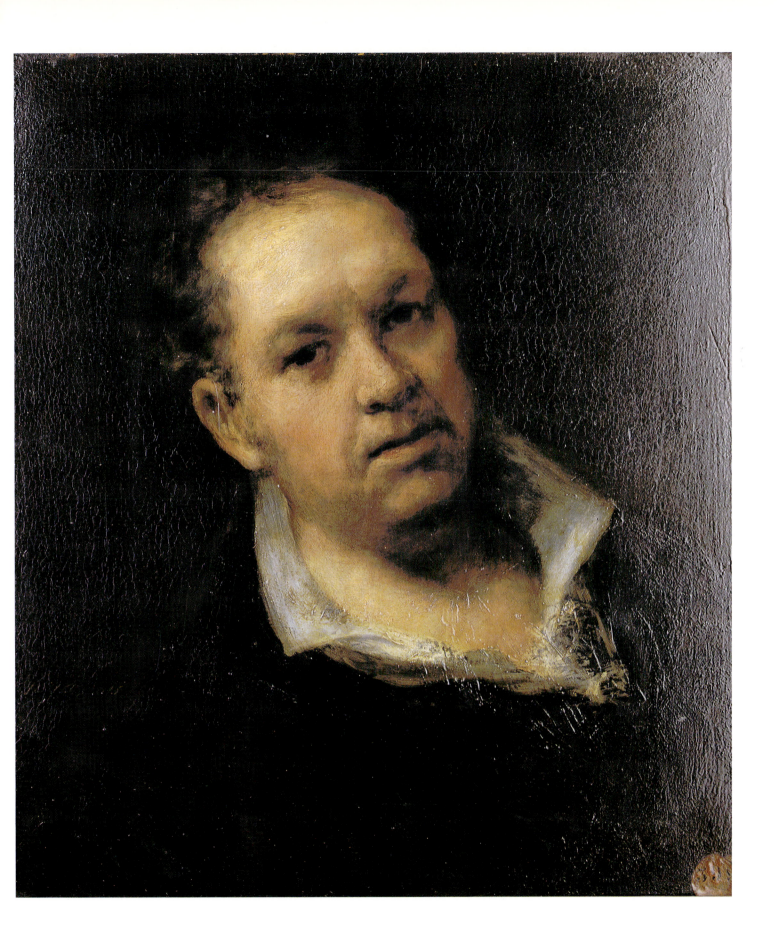

c.1819. Canvas, 191 x 121 cm. Frick Collection, New York

Fig. 39
Three Men Digging
1819. Sepia wash, 20.6 x
14.3 cm. Metropolitan
Museum of Art, New York

The group of blacksmiths is based on a brown wash drawing of *Three Men Digging* (Metropolitan Museum, New York), which belonged to an album dated 1819 by Carderera (Fig. 39). Goya has adapted the figures in such a way that the painting, like the drawing, gives the impression of a study from life. The subject is of a kind that he frequently recorded in drawings; there are many similar documentary scenes of men and women of the people in the 1819 series. As a subject *The Forge* is distantly related to *The Injured Mason* (Plate 2) and similar in character to the small *Water-carrier* and *Knife-grinder* (Szépmüvésze Museum, Budapest), which were in the artist's possession in 1812. However it is unique in Goya's oeuvre as a large-scale close-up view of men at work. The late sketchy style emphasizes the brutish appearance of all three figures and the attitudes of the blacksmiths, suggestive of enormous strength. *The Forge* was undoubtedly an uncommissioned painting, which passed into the possession of Goya's son (see also Plate 25). It was later in the collection of King Louis Philippe and was sold at Christie's in 1853 for £10.

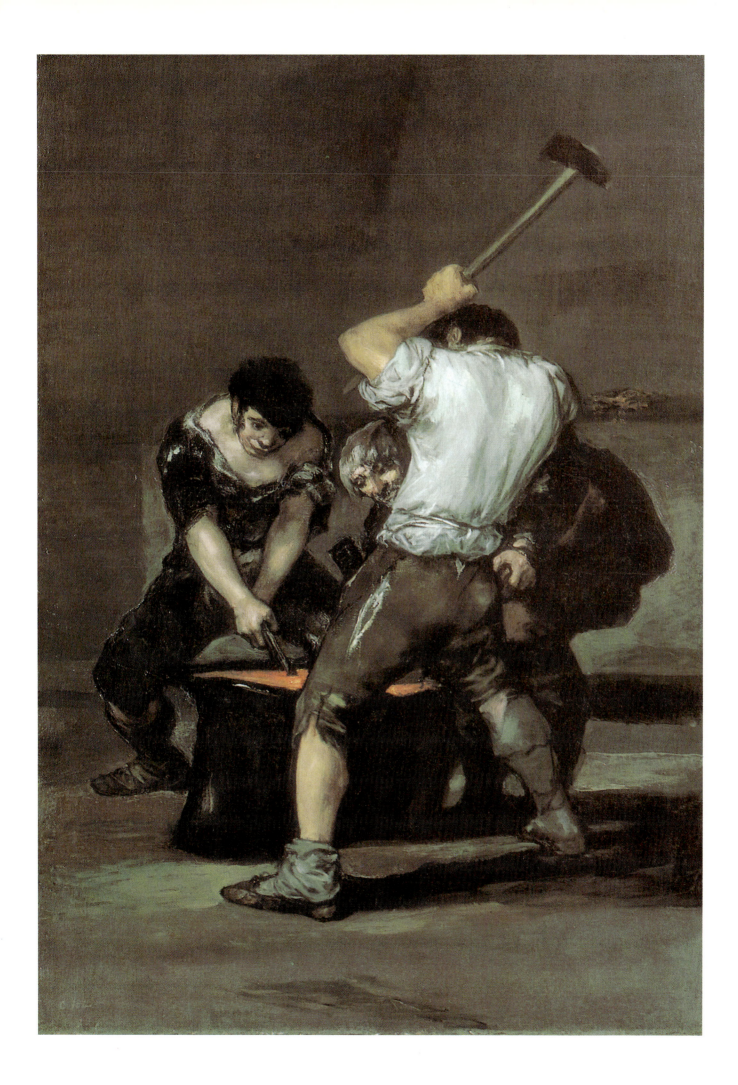

Portrait of Juan Antonio Cuervo

1819. Canvas, 120 x 87 cm. Museum of Art, Cleveland, OH
Signed '*Dn. Juan Anto/Cuervo/Directr de la Rl/Academia de Sn/Fernando/Por su amigo Goya/año 1819*'

The sitter was an architect who was appointed Director of the Royal Academy of San Fernando in August 1815. He wears the uniform of his office and holds dividers, an attribute of his profession. The plan on the table beside him is possibly for the church of Santiago in Madrid on which he had worked in 1811 and which made his reputation. The portrait was probably finished before Goya fell ill at the end of 1819 and is one of his last official portraits. The inscription indicates that it is at the same time a portrait of a friend.

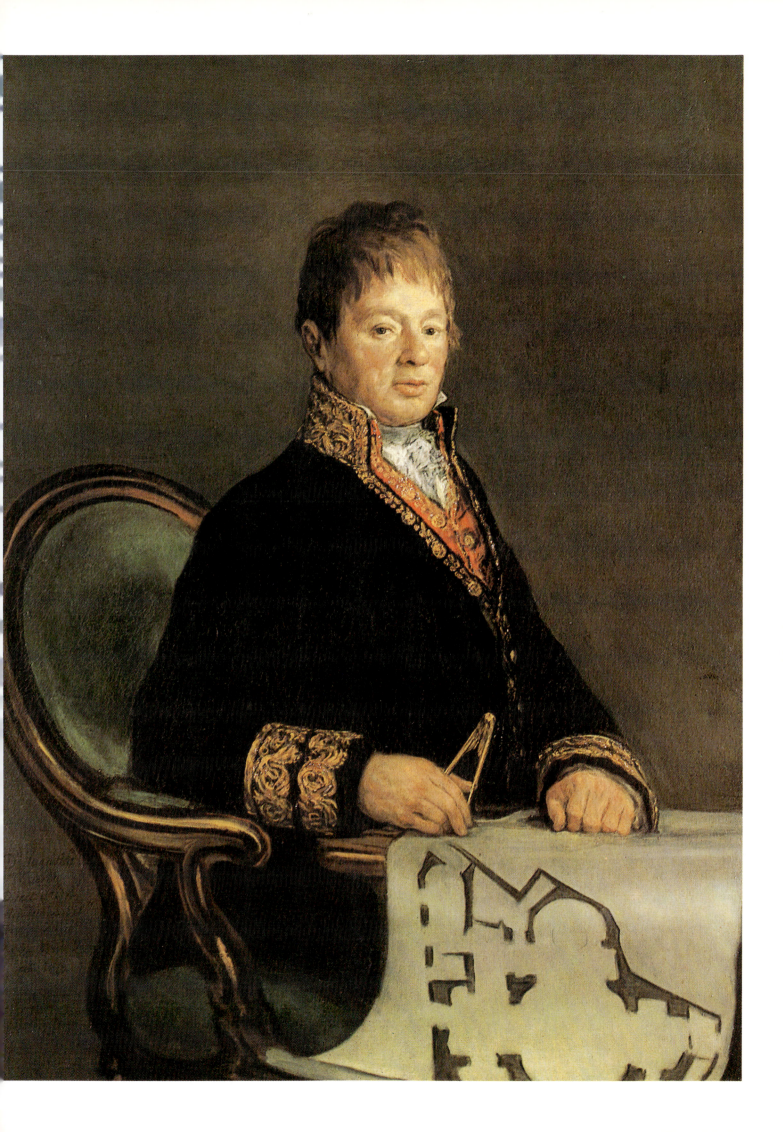

Portrait of Ramón Satué

1823(?). Canvas, 104 x 81.3 cm. Rijksmuseum, Amsterdam
Signed '*D. Ramon Satue/Alcalde d[e] Corte/Pr. Goya 1823*'

The sitter in this painting has been identified as a nephew of José Duaso y Latre, the clergyman in whose house Goya took shelter in 1823 at the end of the liberal interlude. It has been suggested that the date in the inscription has been altered and that the portrait was painted not later than 1820, the last year in which Satué held office as Alcalde de Corte (a City Councillor of Madrid). From the costume, the informal pose and the style of painting it could have been painted either in 1820 or 1823.

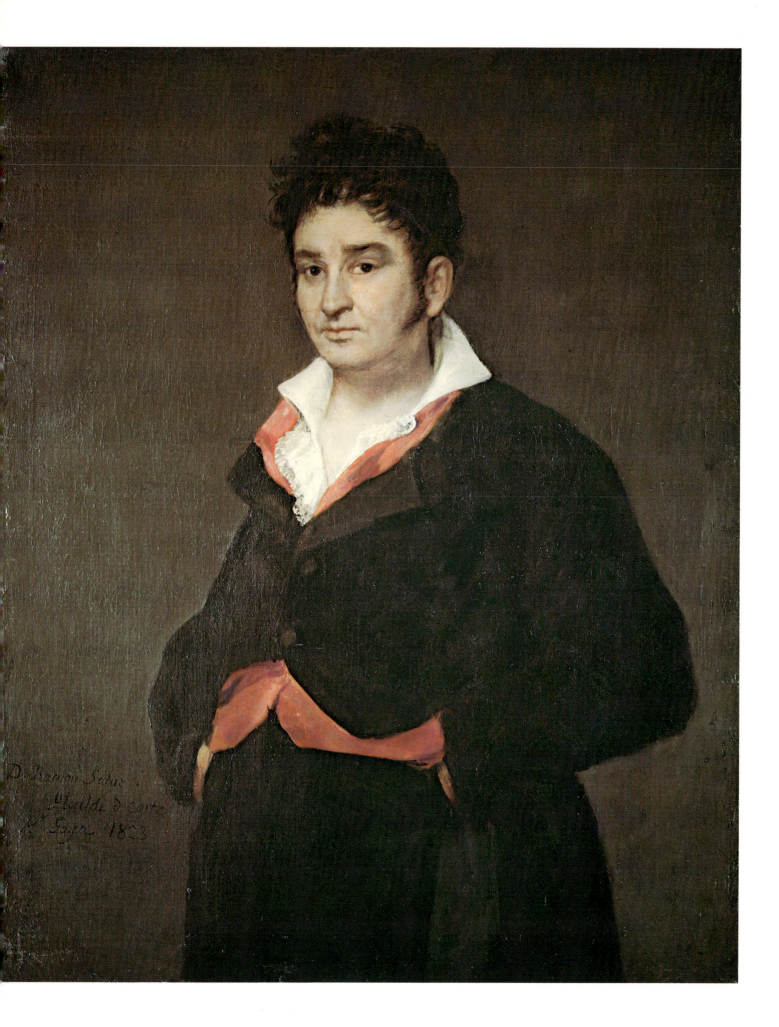

The Last Communion of St Joseph of Calasanz

1819. Canvas, 250 x 180 cm. Church of the Escuelas Pías de San Antón, Madrid
Signed '*Franco. Goya año 1819*'

Fig. 40
The Agony in
the Garden
1819. Panel, 47 x 35 cm.
College of the Escuelas
Pías de San Antón, Madrid

This last ecclesiastical commission for an altarpiece for the Saint's chapel was received in May 1819 to be completed by the saint's day on 27 August. A sketch in Bayonne is said to have been in the Quinta del Sordo at Goya's death. Goya is alleged to have said that this would be his last painting in Madrid, as it virtually was, apart from the decorations of the Quinta and the *Self-portrait with Dr Arrieta* (Plate 43).

When the altarpiece was finished Goya wrote to the Rector returning most of the payment he had received saying: 'D. Francisco Goya has to do something in homage to his countryman', and a few days later he sent as a gift the small panel of *The Agony in the Garden* (Fig. 40). These two paintings are outstanding in Goya's oeuvre for the intensity of the religious devotion they reflect. Goya may well have felt a personal involvement with the saint, who was not only a fellow Aragonese, canonized in Goya's lifetime (1767), but also the founder of the religious schools that are said to have given him his education in Saragossa. This large altarpiece with its highly charged dramatic subject is seen to its best advantage in the dimly-lit chapel for which it was painted.

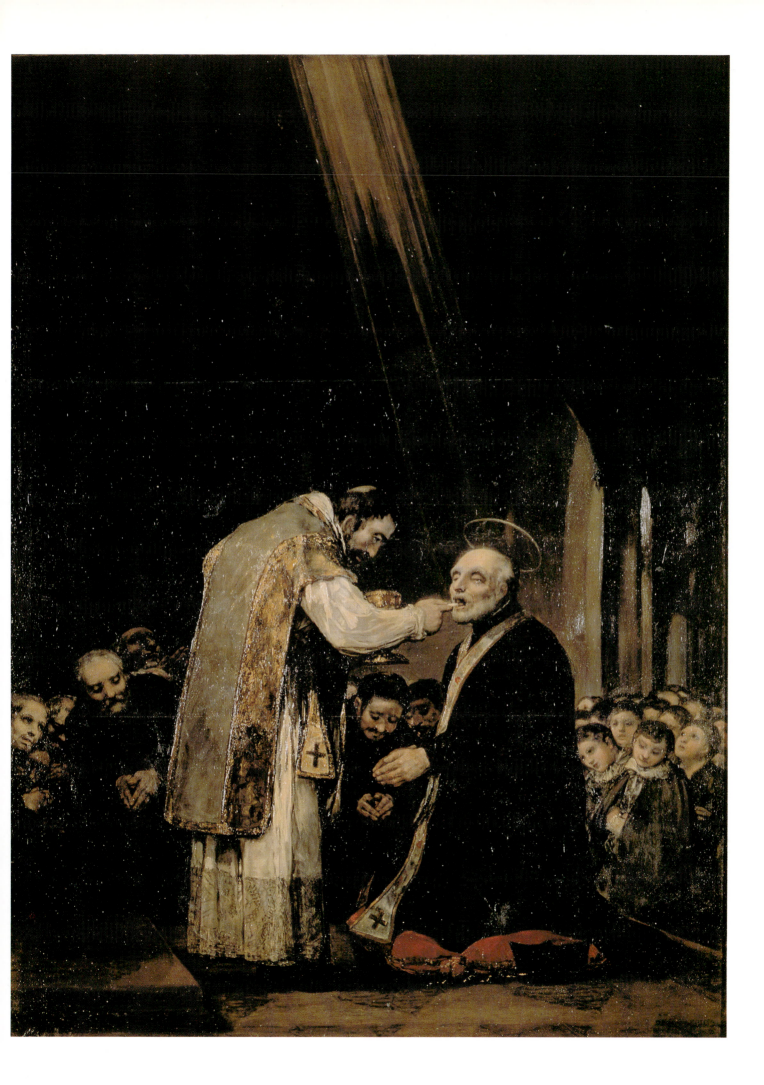

1820. Canvas, 117 x 79 cm. Institute of Arts, Minneapolis, MN
Inscribed 'Goya grateful to his friend Arrieta for the ability and the painstaking care
with which he saved his life in the severe and dangerous illness suffered at the end of
1819 at the age of seventy-three. He painted it in 1820.'

Fig. 41
Of What Ill Will
he Die?
(*De que mal morirá?*)
1799. From the series
Los Caprichos, Plate 40.
Etching and aquatint,
21.7 x 15.1 cm

In this highly original composition Goya has portrayed himself sitting up supported by his friend Dr Arrieta who is holding a glass to his mouth. The shadowy figures in the background are perhaps allusions to nightmare visions conjured up during his illness. They recall the dark figures in some of the paintings with which Goya covered the walls of the Quinta del Sordo, where he was living during his illness, in retirement from the court. Above all, they resemble the attendants of the priest giving communion to St Joseph of Calasanz (see Plate 42). Painted no doubt during his convalescence like the cabinet pictures he painted when he was recovering from his earlier illness of 1793, he has successfully re-created or remembered his appearance when he was near to death: a transformation of his appearance five years earlier (Plate 38). Goya presented his portrait to his doctor, Eugenio García Arrieta, whom he esteemed highly – a far cry from his earlier attitude to the ignorant ass of a doctor, the subject of his *Capricho* no. 40 entitled *De que mal morirá?* (Of What Ill Will he Die?) (Fig. 41). This portrait was evidently admired as a painting or for its subject as two copies were made by Goya's pupil Asencio Juliá. It also was singled out for special praise by his friend and biographer Valentín Carderera (1835): 'The canvas in which he portrayed himself on his deathbed, at the moment when the distinguished Dr Arrieta was giving him the draught which restored him to his country and to his numerous admirers, is a work that recalls all the vigour and mastery of his best years. His likeness of himself in agony and the physiognomy of the doctor, animated by the most benevolent expression, are drawn and coloured with the greatest mastery. Throughout the work it seems that Goya was trying to rejuvenate his talent in order to show the extent of his gratitude.'

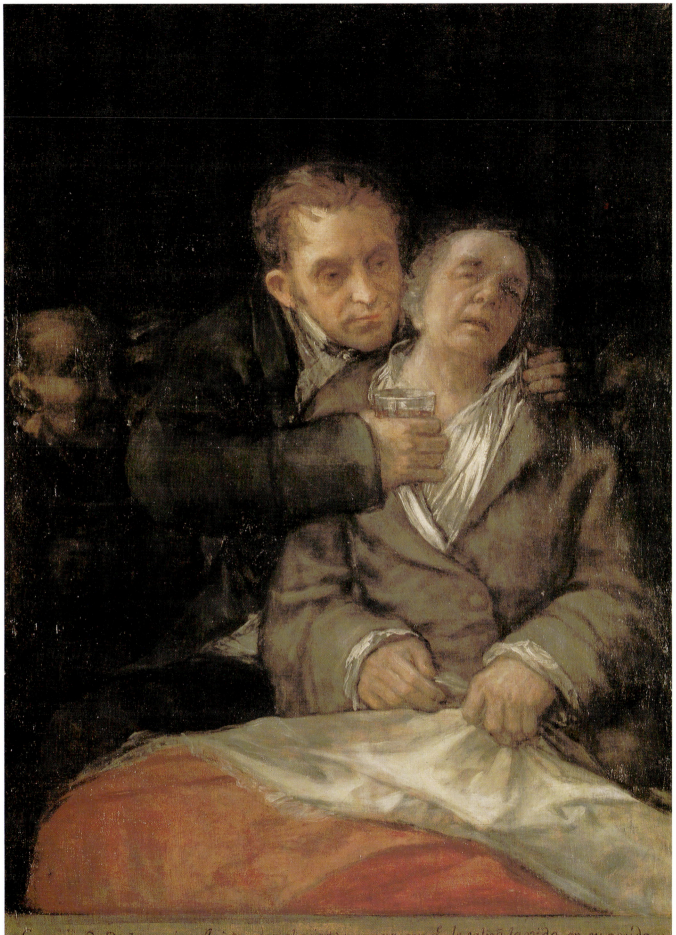

Goya agradecido á su amigo Arrieta: por el acierto y esmero con q.^e le salvó la vida en su aguda y
peligrosa enfermedad, padecida á fines del año 1819. a los setenta y tres de su edad. Lo pintó en 1820.

Tío Paquete

c.1820. Canvas, 39.1 x 31.1 cm. Museo Thyssen-Bornemisza, Madrid

According to Viñaza (1887) the painting was formerly in the collection of Goya's grandson, Mariano, and before it was relined the canvas was inscribed on the back: '*El celebre ciego fijo*' ('The famous blind man'). The same writer identifies the sitter as a well-known beggar who used to sit on the steps of the church of San Felipe el Real in Madrid, and was invited to play the guitar and sing in the houses of members of the court. Goya creates a vivid impression of the blind eyes and jovial expression of the old man in a style close to that of the 'black paintings'. At the same time it is remarkably similar to the manner of Velázquez in his portrayal of the facial expressions of court dwarfs.

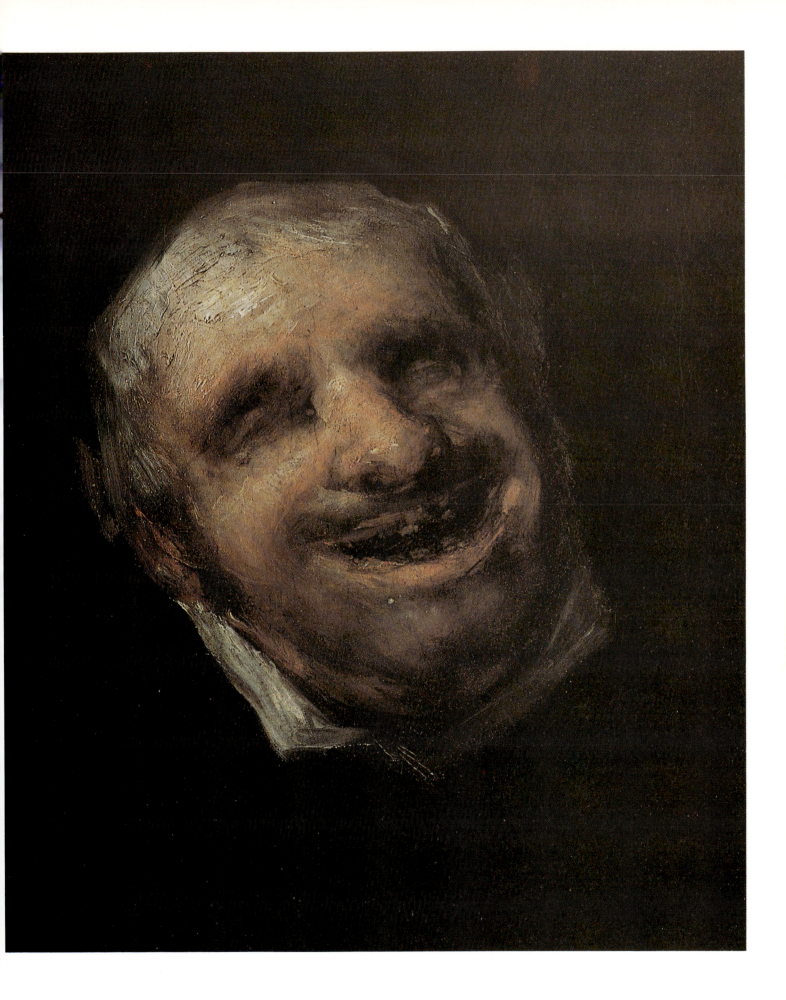

c.1820-3. Canvas, 140 x 438 cm. Museo del Prado, Madrid

The 14 'black' paintings (now in the Museo del Prado), so called because of the dark tones and predominance of black, originally decorated the Quinta del Sordo. They were painted in oils on the walls of two rooms, on the ground floor and first floor, and transferred to canvas in 1873. Goya acquired the house in September 1819, but probably did not begin the paintings before the following year, after his recovery from serious illness. They must have been finished by 17 September 1823, when he donated the property to his 17-year-old grandson, shortly before he went into hiding. Though it is possible to reconstruct the arrangement of the paintings in the two rooms, many of their subjects defy description and the meaning of these sombre, horrific inventions is as difficult to decipher as their appearance is sinister and forbidding. 'The Sleep of Reason Produces Monsters', Goya's title to what was possibly his first design for the frontispiece of *Los Caprichos* (Fig. 20), would have been even more fitting as a title to this array of nightmare visions, created by the artist in his mid-seventies.

The Pilgrimage to San Isidro filled one long wall of the Quinta, opposite a painting called *The Great He-Goat* or *Witches' Sabbath* in the downstairs room of the house. Goya may have been prompted to paint this subject by the fact that the Quinta was built in the neighbourhood of the Hermitage of San Isidro (Fig. 14) and by the recollection of having painted the Hermitage and the Meadow of San Isidro in happier, earlier days (Plate 5). Without knowledge of the title, however, it would be hard to identify the procession of figures moving forward, their features becoming clearer and more awful as they get near, as a procession of pilgrims. Goya's viewpoint in this painting must have been close to that in the Meadow scene, but there is no view of the city in the background.

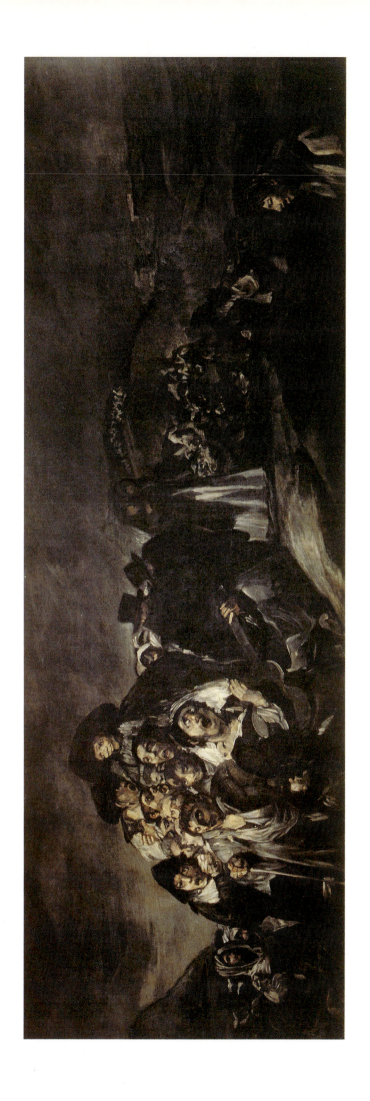

c.1820-3. Canvas, 146 x 83 cm. Museo del Prado, Madrid

Goya's Saturn may have been inspired by Rubens' painting in the Spanish royal collection but, unlike Rubens' mythological figure, Goya's is neither god nor human, a monster with death-like mask devouring a small doll-like figure. It is both more fantastic and more horrific than Rubens' Saturn. Some attempts have been made to interpret individual scenes in the Quinta as history, literature, fable or allegory and to find some theme to fit the whole series. The monstrous inhuman *Saturn*, one of the most striking of all the subjects of the 'black' paintings has been thought to provide a central idea, either as the triumph of ignorance and darkness or as a symbol of melancholy and old age. There is also a possibility that the *Saturn* decorated the dining-room, which would make it a macabre joke. But without documentary evidence – and the earliest record of the paintings, made in 1828, throws no light on their meaning – the key to their mystery is difficult to find. But like the *Proverbios* or *Disparates*, the series of etchings of about the same date, their mystery may have been partly intentional. Their enigmatic, private character certainly contributes to the expressiveness of the compositions and of the manner of painting so that their impact is profoundly disturbing.

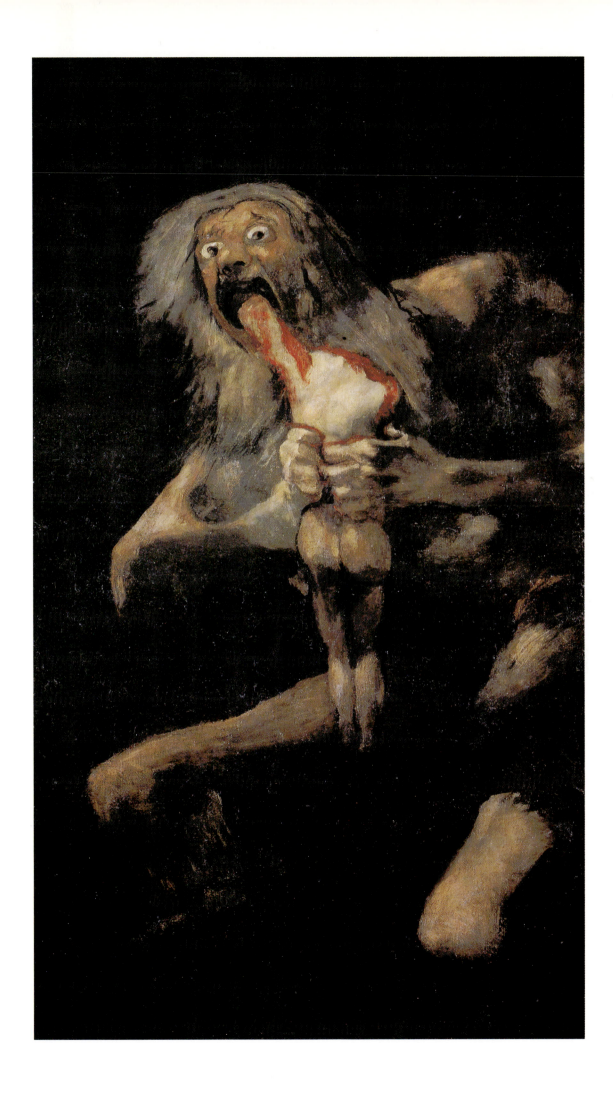

St Peter Repentant

c.1823-5. Canvas, 29 x 25.5 cm. The Phillips Collection, Washington, DC
Signed 'Goya'

The *St Peter* and a half-length *St Paul*, which is probably a pendant, are among Goya's last devotional subjects. In style they are close to the 'black' paintings and must have been made shortly before Goya left Spain or in Bordeaux. This portrayal of an old man praying, in Goya's late manner, is more expressive of religious emotion than many of his earlier representations of saints (see *St Gregory*, Plate 11), relating it to *The Last Communion of St Joseph of Calasanz* (Plate 42) and *The Agony in the Garden* (Fig. 40).

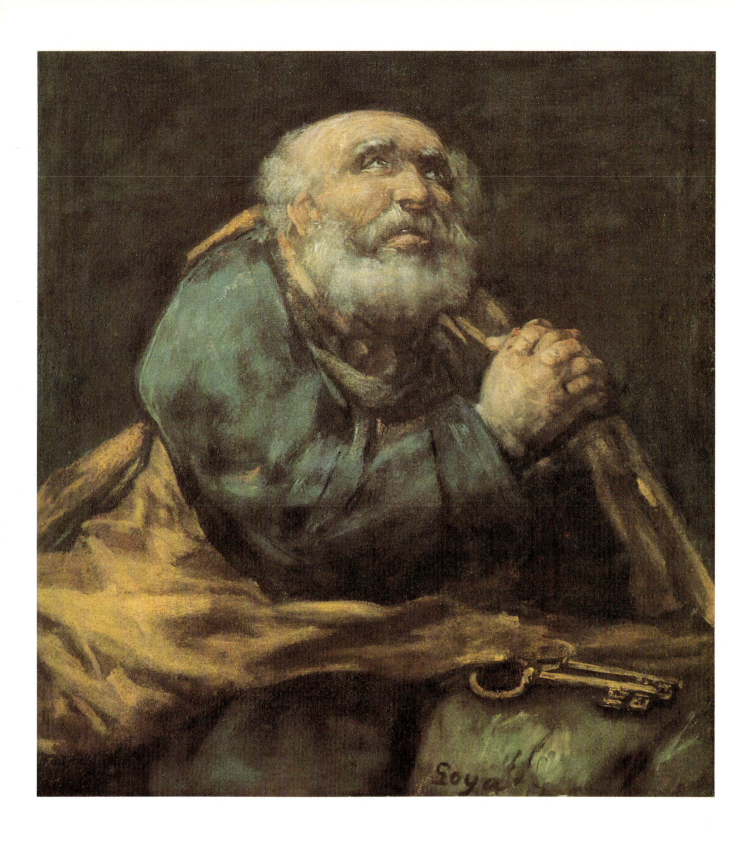

c.1827. Canvas, 74 x 68 cm. Museo del Prado, Madrid
Signed '*Goya*'

One of the last great paintings of Goya's years in Bordeaux, if not the last, *The Milkmaid* strikes a new note, far from the gloom and despondency of the Quinta del Sordo, the obscurity of the *Proverbios* and the records of cruelty and madness in his late black chalk drawings. It recalls something of the light and colour of earlier works made in happier times. Goya, according to his friend and fellow exile Leandro Fernández Moratín, was pleased with 'the city, the country, the climate, the food, the tranquility' that he enjoyed in Bordeaux. A few months later he complains of the artist's 'arogantilla', painting only what takes his fancy and unwilling ever to correct anything that he has painted. Like his cabinet pictures of 1793, *The Milkmaid* is a subject for which there would be no call in commissioned works and it would hardly lend itself to any correction. According to Matheron, in Bordeaux Goya dispensed altogether with brushes, using instead his palette knife and a rag – 'what matter?'. Here is an example of his very late technique used also in his last portraits in which the brush certainly plays a part; brushstrokes that are separate but that combine to re-create the aged artist's vision – with failing eyesight – of the living woman. This painting more than any other has been taken to show Goya as a precursor of the Impressionists. 'Who does not think of Renoir, for instance when looking at this work, which marks the end of the artist's vigorous life, and heralds or begins a whole new age of art?' (Juan de la Encina, 1924, quoted by Glendinning, 1977, p.136). Goya evidently valued this painting highly as he warned his companion Leocadia Weiss not to let it go for less than an ounce of gold, as she told his friend and fellow exile Juan Bautista Muguiro, when she, in great need, agreed to sell it to him in the year after Goya's death.

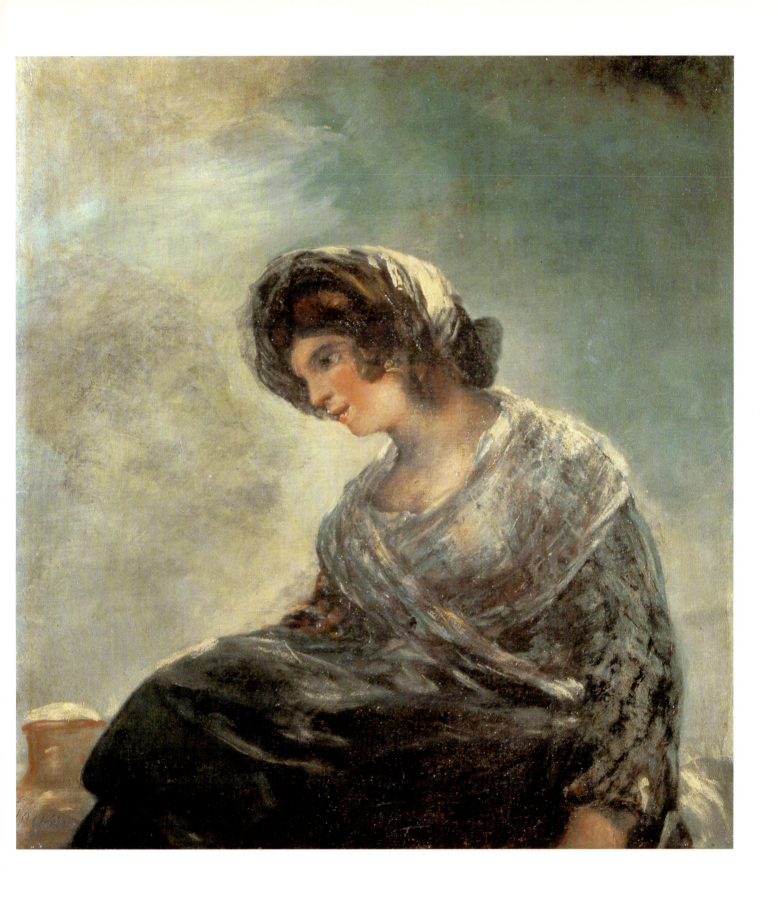

PHAIDON COLOUR LIBRARY

Titles in the series

BONNARD
Julian Bell

BRUEGEL
Keith Roberts

CEZANNE
Catherine Dean

CONSTABLE
John Sunderland

DEGAS
Keith Roberts

DUTCH PAINTING
Christopher Brown

ERNST
Ian Turpin

FRA ANGELICO
Christopher Lloyd

GAUGUIN
Alan Bowness

GOYA
Enriqueta Harris

HOLBEIN
Helen Langdon

IMPRESSIONISM
Mark Powell-Jones

ITALIAN RENAISSANCE PAINTING
Sara Elliott

JAPANESE COLOUR PRINTS
J. Hillier

KLEE
Douglas Hall

MAGRITTE
Richard Calvocoressi

MANET
John Richardson

MATISSE
Nicholas Watkins

MODIGLIANI
Douglas Hall

MONET
John House

MUNCH
John Boulton Smith

PICASSO
Roland Penrose

PISSARRO
Christopher Lloyd

THE PRE-RAPHAELITES
Andrea Rose

REMBRANDT
Michael Kitson

RENOIR
William Gaunt

SISLEY
Richard Shone

SURREALIST PAINTING
Simon Wilson

TOULOUSE-LAUTREC
Edward Lucie-Smith

TURNER
William Gaunt

VAN GOGH
Wilhelm Uhde